# Yellowstone Memories

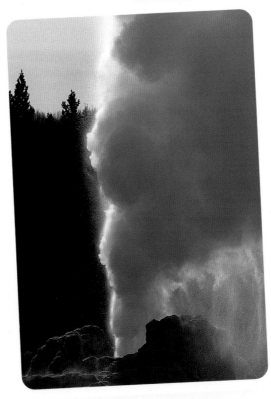

*Best regards,*
*Michael H. Francis*

*by Michael H. Francis*

## 30 YEARS *of* PHOTOGRAPHS *&* STORIES

SELECTED BOOKS PHOTOGRAPHED BY MICHAEL H. FRANCIS

*Mule Deer Country*
*Elk Country*
*Wild Sheep Country*
*Into the Wind ... Wild Horses of North America*
*Track of the Coyote*
*Antelope Country*
*Whitetail Tracks*
*Moose*
*Bison for Kids*
*Moose for Kids*
*Wild Horses for Kids*

---

Copyright © 2005 by Michael H. Francis
Published by Riverbend Publishing, Helena, Montana.
Printed in South Korea.

1 2 3 4 5 SI  09 08 07 06 05

Cover and text design by DD Dowden
ISBN 1-931832-59-5
Cataloging-in-Publication data is on file at the Library of Congress.

RIVERBEND
PUBLISHING
P.O. Box 5833
Helena, MT 59604
1-866-787-2363
www.riverbendpublishing.com

# DEDICATION

*This book is dedicated to my wonderful and supportive wife Victoria—*

*my Yellowstone maiden! Also to our daughters, Elizabeth & Emily.*

*To my many Yellowstone friends, both human and animal.*

*Thanks for thirty fun-filled years.*

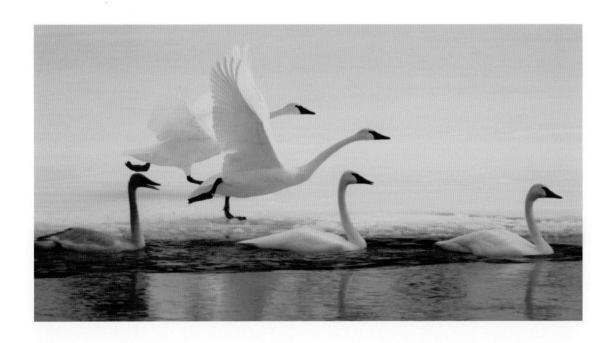

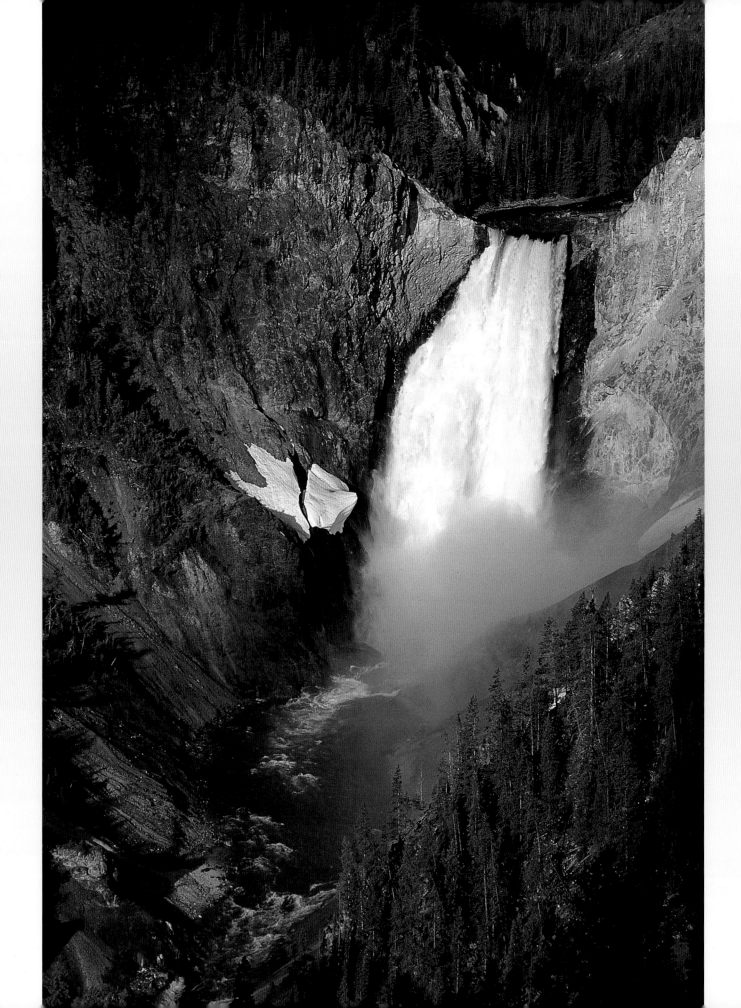

# My Yellowstone memories

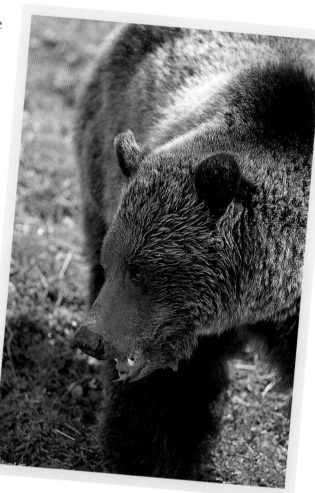

Welcome to Yellowstone National Park, my favorite place on earth. I have been privileged to photograph Yellowstone for the past thirty years.

For fifteen of those years I worked in the park as a seasonal employee for the concessionaire. I started out working in the laundry at Lake Lodge. Through the years I was a room attendant, truck driver, kitchen helper, laundry manager, and eventually a lodge manager.

Working in the park allowed me to be out in the field at every opportunity, exploring the park and honing my photographic skills. There was no better place to learn photography. Every day I could go out and try it all over again. Nowadays I'm often asked how I ended up as a professional nature photographer. I can tell you in one word: Yellowstone.

Like many folks in the mid-1970s, I came to the park with a small Kodak Instamatic camera. On one of my first days in the park I had the good fortune to view a grizzly bear from the safety of the road. As the bear stood upright in an open meadow, I snapped the shutter once. In those days I thought that one photo was enough—foolish me. I recall that shot as if it were yesterday. I was so excited to show my first grizzly bear photograph to my new friends. When I got back the print and showed it around, everyone asked me if it was a picture of a gopher! That's when I knew I needed a new camera and a telephoto lens. My first paycheck went for a Fujica 35mm camera and Bushnell 300mm telephoto lens.

I have been carrying a camera (now it is digital) ever since that early summer day in 1974. What started as a hobby quickly turned into a business. First I did slide shows for employees, than guests, then I entered and won photo contests, and finally I started selling images to national magazines.

While I was working summers in the park I was also going to college. I received a Bachelor of Science in entomology from Montana State University and attended college an additional three years towards a degree in film and television. My dream of combining the two disciplines for a career in nature photography has worked. Now after publishing twenty-eight books I'm back to the one I started thirty years ago but didn't realize it at the time.

*Yellowstone means many things to millions of people, but I think most of us would agree that Yellowstone has four great icons: the Lower Falls of the Yellowstone (facing page), a grizzly bear (above), bison and Old Faithful Geyser, both found later in these pages.*

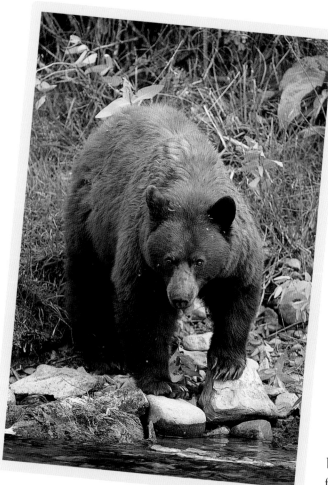

I've noticed that black bears, including the brown-colored one above, are more commonly seen today than they were thirty years ago. That's good news for park visitors, even if they come for other pursuits like fishing in the Yellowstone River (facing page).

I don't claim to be a writer so I hope my images speak for themselves. But I do have some stories to tell. They go along with my photos or happened while I was working in and exploring the park. For example, one night while hiking to the road after a long day in the mountains, my hiking partner and I saw the glow of a campfire. This small fire piqued our curiosity because we knew there were no backcountry campsites in the area. We yelled out a greeting and were welcomed into the camp. The first questions from the young couple were, "Do you know where we are? Are you lost too?" I replied that no, we were not lost and we were really quite close to the road. I pulled out my topographic map and showed them where they were camped. When my buddy and I said we were going on, the pair couldn't believe we would leave them there! They had been lost on the hillside for two nights! I gave them my map and showed them exactly how to hike out. I also told them I would alert the park rangers. They were not happy to be left behind, but they would not leave the safety of their tent and fire. The next day they walked out.

I've happened upon some odd things in the backcountry. One time in the 1970s I found a man's wallet far from any trail. It was still in fair condition and had been there since the early 1960s. I never found out how the wallet got there. Another time I sat down to rest on what turned out to be a petrified log. On closer inspection I found a perfectly formed crystal leaf, thousands of years old.

For more than one hundred years tourists have been visiting Yellowstone and saving their memories in scrapbooks so they could relive their fun moments in the park with friends and relatives. I invite you to enjoy my scrapbook of this special place.

## ABOUT WILDLIFE PHOTOGRAPHY AND WILDLIFE VIEWING

Not only have I witnessed ecological changes in the park over the past thirty years, I have seen—and endorsed—major changes in photo equipment and the ethics of wildlife viewing and wildlife photography.

When I first started photographing wildlife, the longest lens I owned was 300 millimeters. Today most professional photographers use at least a 500mm lens and in many instances use a 600mm lens with a multiplier. This allows us to photograph from a greater distance and without disturbing the animals.

Thirty years ago I rarely saw a visitor with a spotting scope. Today many park visitors utilize spotting scopes and binoculars to watch wildlife from safe and non-disturbing distances.

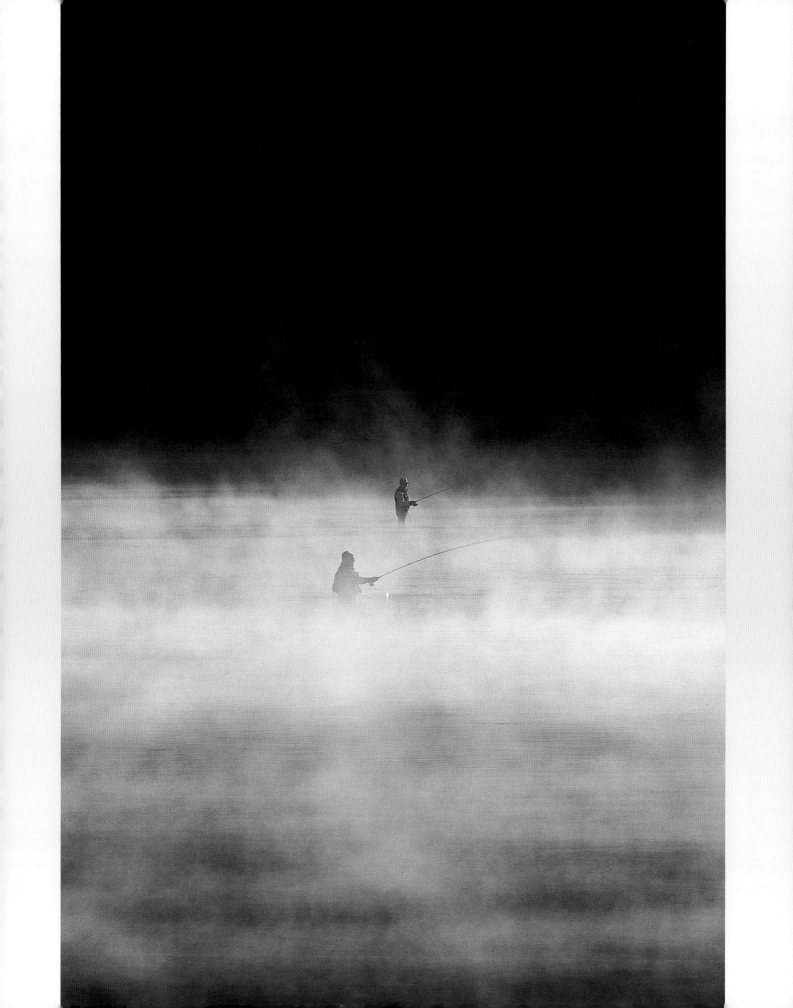

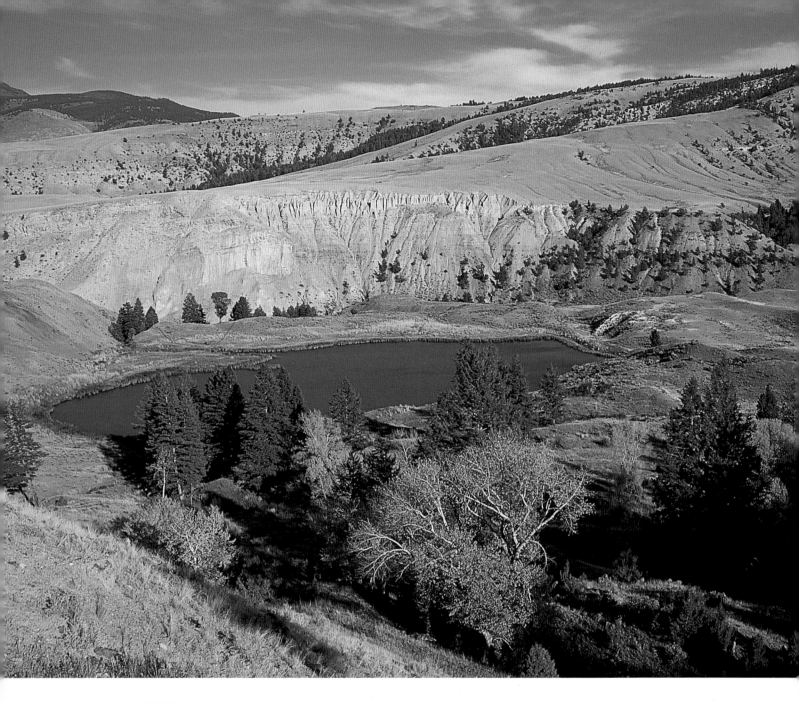

ABOVE: *Yellowstone's backcountry is vast and varied. The open country around Slide Lake just north of Mammoth is one of my favorite spots.*

From years of experience, I have learned that many of the best wildlife images are taken from the safety of a road and a vehicle. Animals will often ignore or at least tolerate a stationery vehicle but will move away (or occasionally charge) when a person approaches on foot. So it is not only safer to stay in your car, it usually results in better photos.

Most of the close-up images of bears and other wildlife in this book were taken from my vehicle. I would never think of approaching large animals so closely on foot. Such behavior is dangerous, it is against park regulations, and it disturbs the animals. We tend to forget that each time an animal is disturbed, it is losing an opportunity to eat, rest, or care for its young. I hope all visitors and photographers put the welfare of the animals first and foremost.

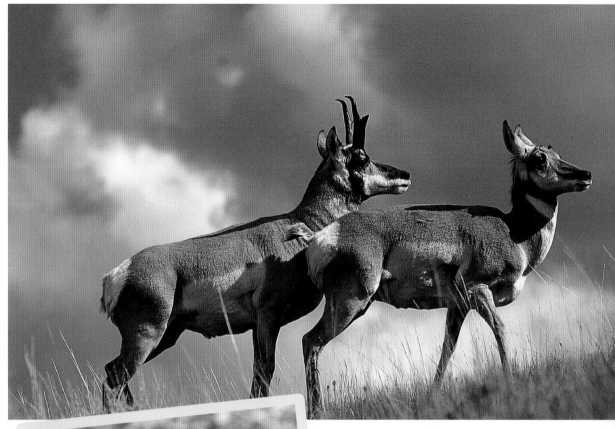

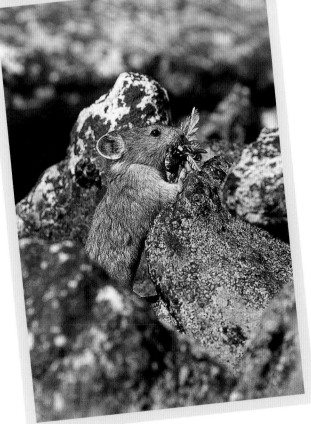

Pronghorn antelope (a male and female, above) most commonly inhabit grasslands in the park's lowest elevations, but little pikas (like the one at left) inhabit rocky mountainsides at the highest elevations. In the summer pikas gather vegetation to build small "haystacks" that they eat during the long winter months.

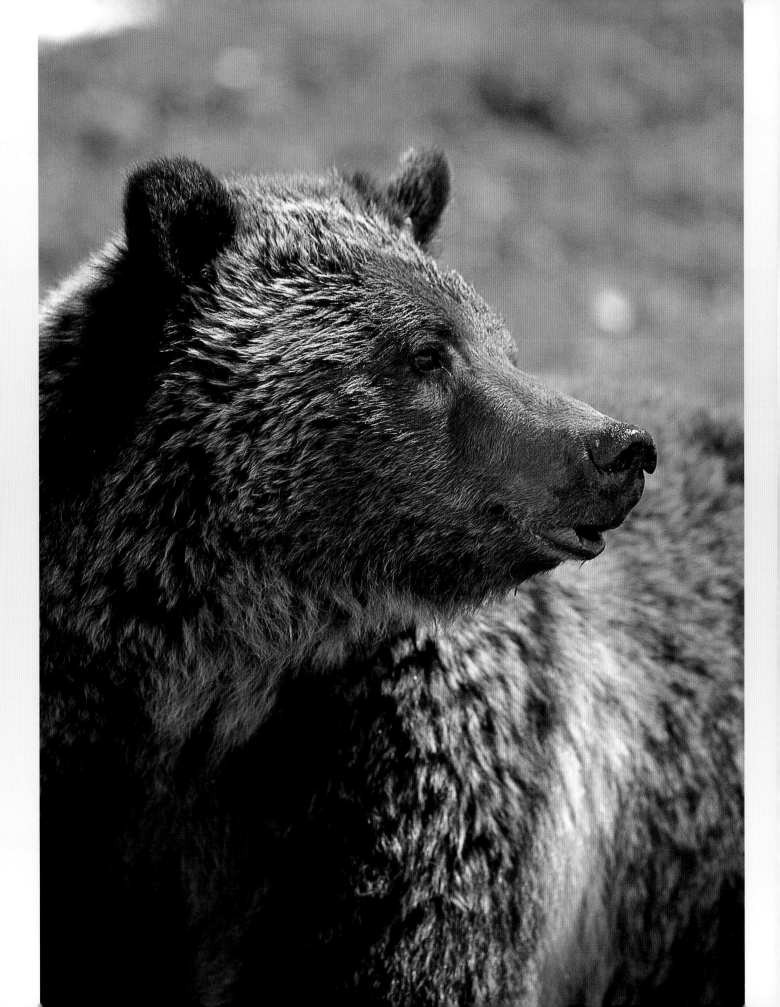

# Grizzly bear memories

*Then:  When I first started working in the park, grizzly bears were only seen on rare occasions, mainly in Hayden Valley during the evening hours. As the years went by, I discovered backcountry areas where I could watch grizzlies from a distance. Through the years many of these areas have been closed seasonally and reserved for the bears and other wildlife.*

*Now:  Grizzlies are more commonly viewed from the road than they were thirty years ago. I commend the National Park Service because in recent years they adopted a policy of controlling park visitors rather than moving bears. This has resulted in many fine roadside-viewing opportunities, not only for visitors but for professional researchers and photographers as well.*

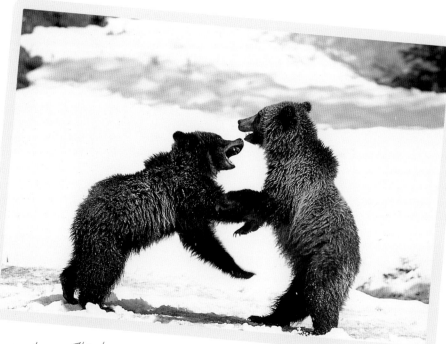

*To me, grizzly bears are Yellowstone. I photograph them whenever I can. In recent years, many visitors and I have had wonderful opportunities to watch grizzly bears from the park's roads— and the safety of our cars—as shown by these photographs. Above, twin two-year-old cubs play fight in the snow.*

## A GREASY GRIZZLY

A funny incident happened with a grizzly in the Lake area just before the hotel and lodge closed for the season. A bear managed to pull a manhole cover off a kitchen grease pit and crawled down inside. But the bear couldn't climb out because everything was coated with slick grease. The frustrated bear started raising a ruckus, which attracted a lot of attention. Numerous items were lowered into the pit to help the bear climb out, and a small tree with branches finally worked.

## A DREAM COME TRUE?

One day in the early spring of 1982, my friend Ron Shade and I decided to look for bears on Swan Lake Flats. The night before I dreamed that Ron and I came across a sow grizzly with triplet cubs. In the dream the bears charged. There was a small tree in the distance. Having longer legs than Ron, I reached the tree first, but the spindly tree could only hold one person. As I climbed I looked back to see my friend being torn apart by the bears.

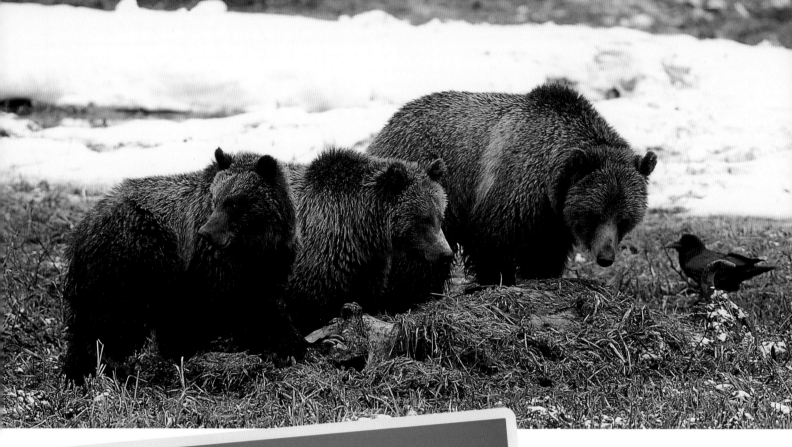

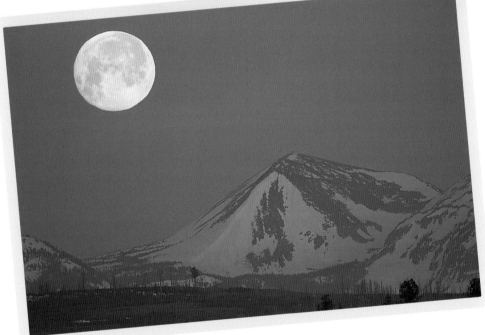

ABOVE: *A mother grizzly and her two-year-old cubs, newly out of hibernation, feed on a bison carcass. They have partially covered the carcass with vegetation.*

LEFT: *A full moon shines over mountains above Swan Lake Flats, scene of a very memorable encounter with grizzly bears. See "A Dream Come True?"*

That morning I met Ron at Swan Lake Flats. In the distance we spotted a large, dark-colored grizzly having fun sliding down a snowy slope. We decided to try to photograph it. When we got to the base of the hill, a grouse flew up right in front of me. I thought I was having a heart attack. In the meantime the bear had disappeared into thick cover and we gave up. Later while having lunch on a ridge, I told Ron about my dream. We both had a good laugh.

The day had turned rainy and cold so we started back to the vehicle. As we walked across the sagebrush flat, my friend thought he saw a bear on a timbered hillside. I looked through binoculars and saw two bears, then three, and finally four—a sow grizzly with three large triplets!

The bear family came out of the trees and headed towards an elk carcass. Then the mother bear spotted us and took a couple of steps in our direction. We started to walk away, but the sow and cubs started running towards us down the hillside. We stopped and they stopped. Then we walked and they ran towards us. We stopped again and they stopped. It was starting to get a little scary. On the sagebrush flat there was nowhere to hide. Off in the distance was—you guessed it—a small, spindly tree. It wasn't big enough for two people. We quickly walked towards the tree, and I started to get ahead. As we got closer, Ron said, "Damn it, Mike, I know how this ends! Wait for me and we'll face off the bears together!"

The bears were getting very close. We stopped, set up our tripods in front of us, opened our coats and stretched out our arms to look as large as possible. The bears approached to within a couple of seconds, then they stood up. For a very tense moment four grizzlies looked us over. Then they dropped to the ground and walked back to their elk meal on the hillside. Excited, to say the least, we left without taking any close-up photos! Now before we go on photo shoots, Ron asks me if I have had any dreams he should know about.

## DREAM OR WARNING?

Talk about a nightmare. While taking a midday nap in the woods on a day off, I just about gave up photographing bears for good. I was near an area where I had often found fresh signs of grizzly bears. I thought a grizzly photo

BELOW: *A big grizzly steps into the sunlight of a small opening on a hillside. Any appearance of grizzly is impressive. A sudden appearance is heart stopping.*

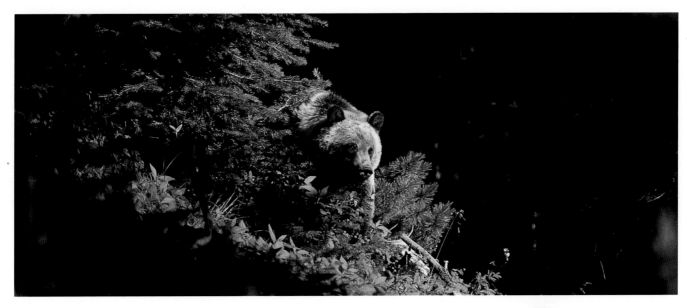

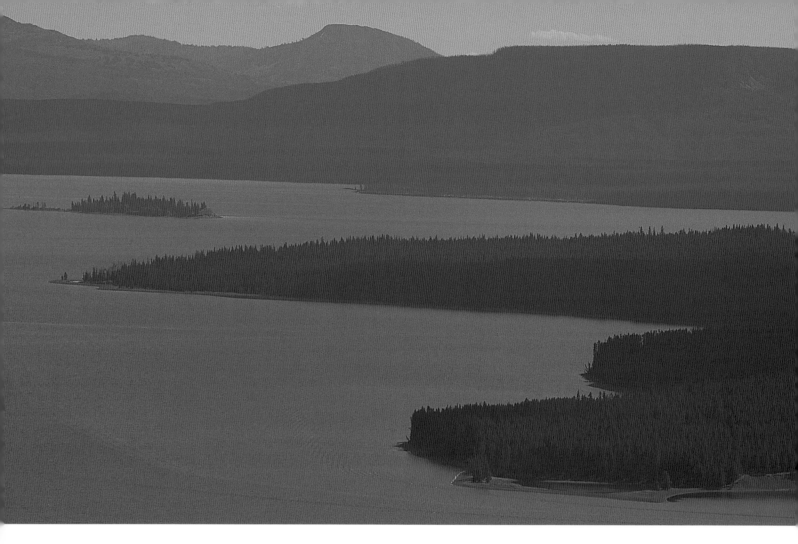

*One of my favorite views of Yellowstone Lake is from the top of a ridge called Elephant Back. Like nearly all of Yellowstone, the area around the lake is great bear habitat.*

in that scene would be great, but since the area was wooded, I also knew I could run into a bear at close range. In the dream a bear ambushed me as I walked through the woods. The dream was so vivid I could feel the bear's teeth puncturing my skull. After the mauling I could hear the blades of a helicopter as it searched for me. I woke up in a cold sweat and left the area as fast as I could. I have never gone back and have no intention of ever going back. That dream was just too real.

## TWO-MAN TENT FOR FOUR

On a backpacking trip on the Thoroughfare Trail around Yellowstone Lake, my wife and I were surprised to find two women from work sharing the same backcountry campsite. In the afternoon the four of us took a short hike near camp. As we walked along a small stream, a pine martin chattered at us, as if warning us of nearby danger. We turned back to camp and discovered grizzly bear tracks on top of our own fresh tracks! That evening the campfire stories were about bears, of course.

The two women had a "tent" that was basically a piece of plastic open at both ends. As they crawled inside, I thought they would look like a big hot dog if the bear came back. Our tent was a comfortable two-person tent, completely enclosed.

After I settled into my sleeping bag and was about to fall asleep, I heard a rap tap-tap on the door. Before I could say, "who is it," both girls pushed their sleeping bags inside and begged to spend the night.

With four in the tent it was a tight squeeze, and I had a restless sleep. During the night I was awakened by the sound of something sniffing the tent next to my head. It sounded like a pig grunting, and I could hear it moving around the tent. I wondered whether I should wake the girls. No, I decided, and went back to sleep. In the morning we found fresh bear tracks all around the tent!

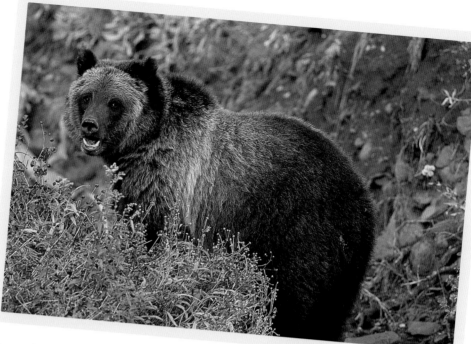

ABOVE: *This young grizzly was feeding along a small stream when it looked back at me. Then the bear went back to the more important task of eating. Autumn is a critical time for bears to put on fat to survive the long winter months in hibernation.*

## "PLEASE BEAR, DON'T EAT US"

Many of my fellow employees knew I was constantly hiking during my off hours, and I was usually hoping for a glimpse of a bear. Needless to say, lots of folks tried to tag along. Two friends finally convinced me they could keep up and would follow my directions. The hike was extremely strenuous and we wouldn't return until well after midnight. I asked both men to bring sack lunches and flashlights.

The hike started out well with plenty of bear sign, mostly large pits where bears had been digging roots and ground squirrels. At one point I was checking on some old bones while the guys moved ahead. I looked up and saw a grizzly bear moving along the slope not far from my friends, but they couldn't see it. I waved and waved until they finally noticed me. I motioned for them to climb a tree. Their climbing was like a Laurel and Hardy comedy routine. They climbed, broke branches, and slid down the tree, then climbed again and again with the same result. Good thing for them the noise scared away the bear rather than attracted it.

As the bear entered some timber, it flushed out a large bull elk. The guys saw the elk and thought I had been pulling a prank on them. It took awhile to convince them there really had been a bear.

We started for home. We had to drop down one mountain and then up another one through timber and deadfall. It was dark, and when I asked for the flashlights they produced one tiny penlight. Luckily we did have moonlight. Going through deadfall on the mountain was not fun. When we finally reached an opening suitable

for a break, neither of these "in shape" guys wanted to get back up. I believe I heard "leave me here to die" from one of them. It really was an exciting walk through the dark forest after seeing a grizzly bear. There was a lot of calling out, "please don't eat us bear."

## "IF SHE CHARGES, JUMP OFF THE CLIFF!"

For a couple of years I spent considerable time trying to get to the top of as many 10,000-foot peaks as possible, sometimes bagging two or three summits in an evening after work. These hikes were more like runs because my hiking partner and I usually raced to the top. One evening I happened to be in the lead on a mountain ridge. Just as I came over a rise I saw a large animal in my path. My first thought was giant porcupine, but there are no four-hundred-pound porcupines. It was a sow grizzly with a spring cub. The bears and I made eye contact at the same time.

I came to an abrupt stop about thirty feet from the bears. My friend bumped into me as I said, "Stop. Bear." I'll never forget the sight as the young cub squeezed itself between its mother's front legs and stared at us. On our right was a cliff and on our left the sun was setting. I whispered, "If she charges, jump off the cliff and try to catch yourself on the way down." After a tense moment, the sow and cub walked away into the sunset, never looking back. I didn't have a camera, but the picture of that cub between its mother's legs has been forever framed in my mind.

BELOW: *I've always been impressed by how comfortable and nonchalant bears can look when they are resting, compared to how alert and powerful they appear at other times,*

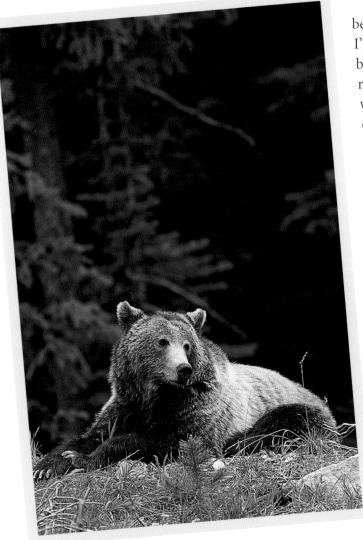

FACING PAGE: *It's not hard to remember this day. Before sunrise on April 1, I met a good friend in Gardiner. When I asked if he had found anything good for us to photograph, he said yep, a grizzly bear would be just off the road. I laughed and said, yeah right, April Fools. Turns out he was serious. We spent the better part of the day photographing this young female grizzly feeding on a winter-killed bison at Floating Island Lake. It was the earliest date in the spring that I've ever seen a bear in Yellowstone.*

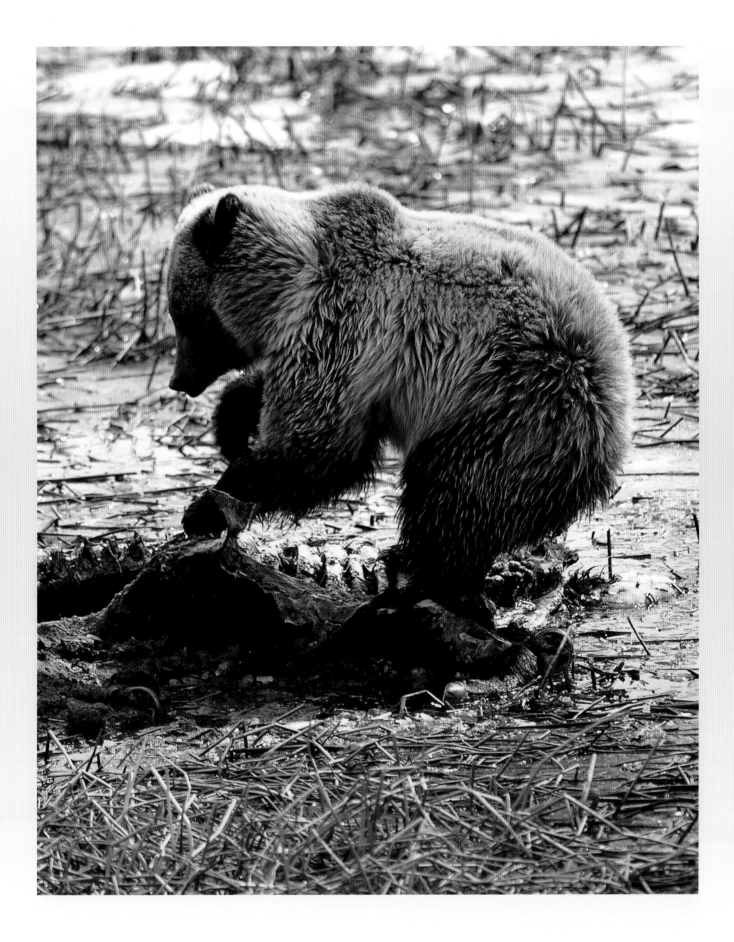

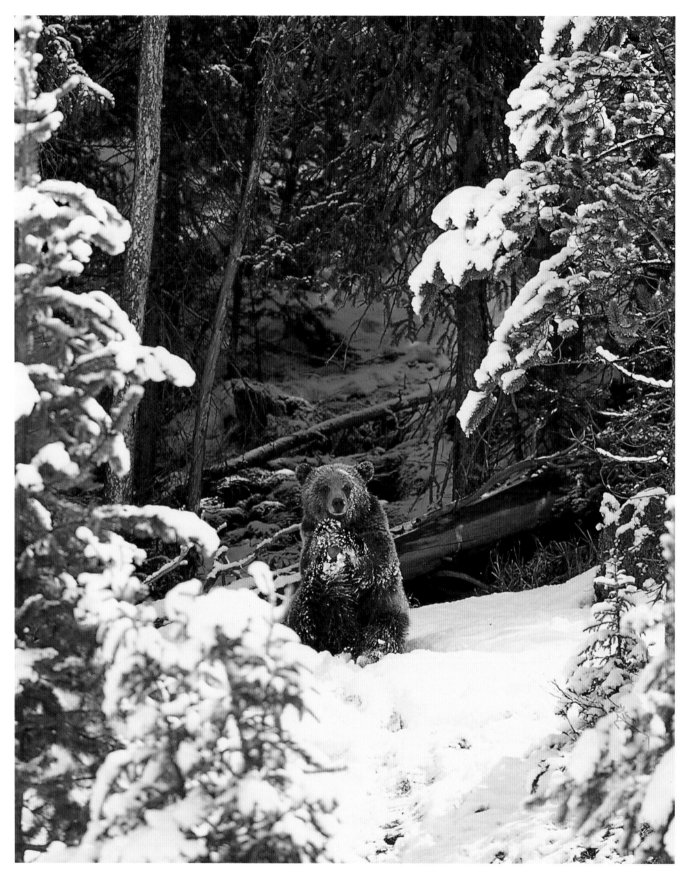

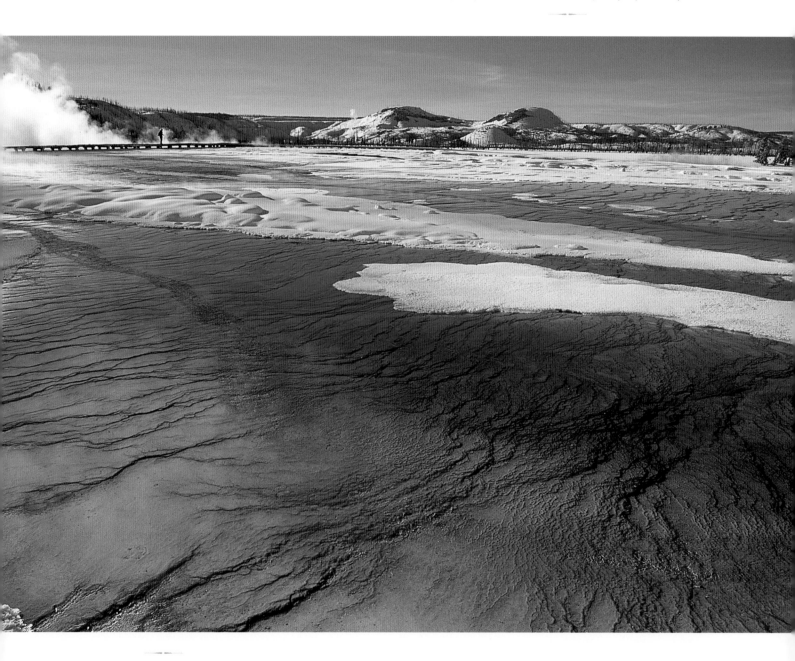

FACING PAGE: *A grizzly bear in the woods, playing with some fresh snow. One of the best times to see bears is in the spring as soon as the roads open.*

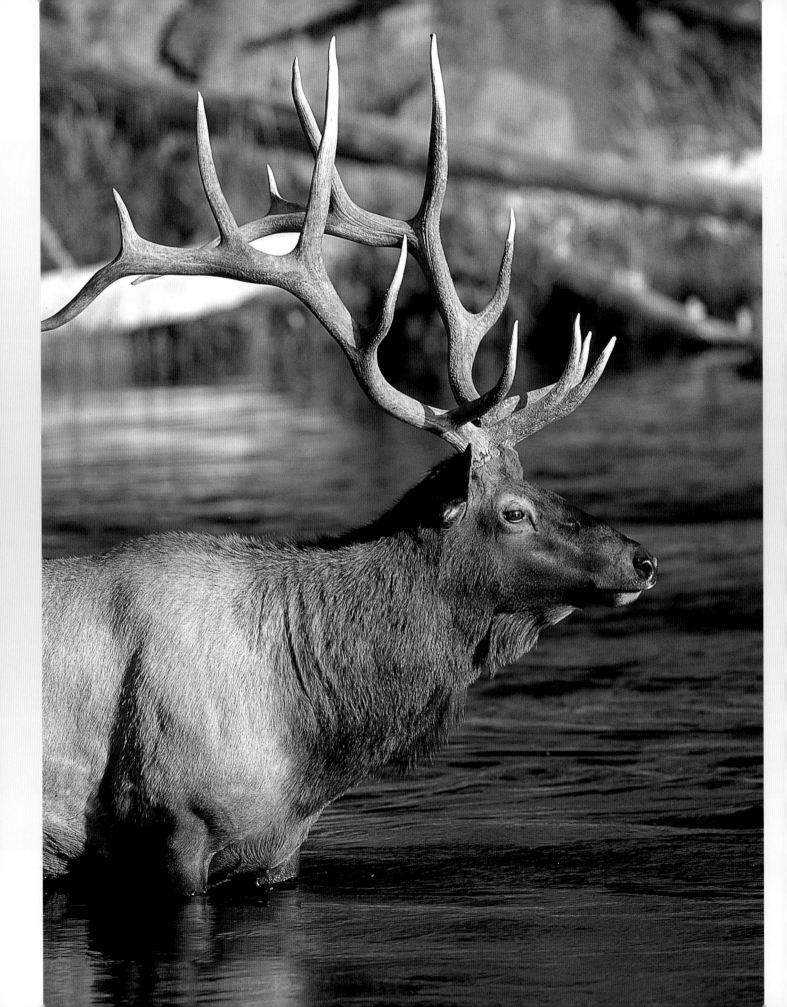

# Elk memories

*Then:   When I first started coming to Yellowstone, elk were numerous, and it seemed like their numbers increased through the years.*

*Now:   Elk numbers are still high, but with the extended drought and the re-introduction of wolves, I believe I am seeing a slight decrease in the overall elk population.*

## IN THE RUT

Generally elk are pretty calm creatures, and a bull elk in velvet antlers is one of the more majestic sights in the park. But during the fall rut when testosterone-crazed bulls are chasing females and fighting off rivals, they can be aggressive. I have seen and heard of folks getting too close and being charged and injured by rutting bulls. One autumn I was almost on the receiving end of those antlers, or so I thought. A large group of visitors were watching a bull in the Madison River. They were on the riverbank just above him and I thought they were too close. Having a long lens and tripod, I set up at least a hundred feet away. Suddenly the bull charged up the bank, splitting the group of onlookers in half. People were running in all directions but instead of chasing one of them, the bull ran straight towards me at full throttle. I could hear people yelling and screaming, certain they were about to view a goring. Not really having time to move, I stood my ground with the tripod in front of me. In the back of my mind I wondered if I might be able to grab the antlers instead of having those tines go through me. As the bull got close I vividly saw his wild and bloodshot eyes. I'll never forget them. The bull slowed down, looked at me, walked around behind me, and then lay down less than ten feet away. I managed to take a few photos before I moved away.

Another time a well-known outdoor writer somehow got himself too close to an ill-tempered bull. The bull chased this guy around and around some small trees until a group of photographers, including me, went over and distracted the bull long enough for the writer to reach safety.

My motto during the elk rut: the longer the lens the better.

ABOVE: *I couldn't resist this "in your face" photograph (thanks to a telephoto lens and safety of my vehicle) of a cow elk. This is wildlife watching, and vice versa.*

FACING PAGE: *I like elk. I've probably taken more photos of elk than any other species in the park. This great bull had seven points on each antler. Most mature bulls have six points per antler.*

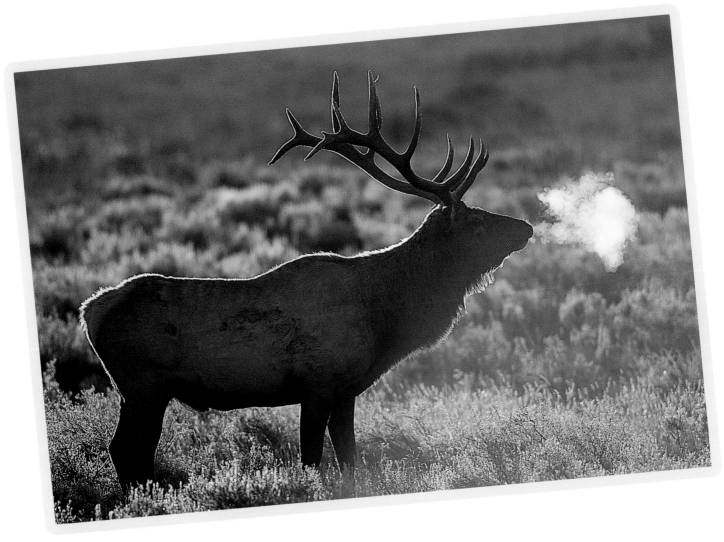

The difference between these elk is probably six to eight years, maybe more. The calf (right) has a long ways to go and many obstacles to overcome to reach the size and status of the herd bull (above).

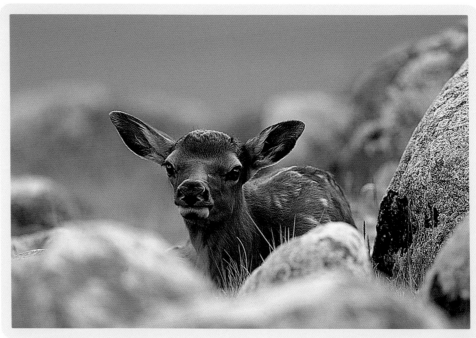

## POACHERS

On a sadder note, every year there are roadside bulls killed by poachers. A number of times I have been first on the scene to find the remains. On several occasions my photos have been used in court to convict the criminals. Some of the animals were killed only for their trophy antlers, while others had the front and hind quarters removed for the meat and the antlers left behind. It's sad to think there are folks who think Yellowstone is their private hunting preserve.

## IS CHIVALRY DEAD?

One of my most amusing elk sightings took place at Lake. While watching a bull from a distance, I saw two young couples leave their car and approach the bull. On the way they had to hop over a small stream. When they got close, the bull turned towards them, lowered his large antlers, and charged. All four people turned and ran. One of the women tripped and fell in the stream, and the "gentleman" behind her just jumped over her and kept running. She got up with a strange look on her face and I'm sure she had words with him back in the vehicle! The bull hadn't moved more than a couple of feet and, like me, just watched the whole thing.

BELOW: *In early spring these bulls have shed last year's antlers and have just started growing new ones. So they attempt to settle a dominance dispute by rearing up and striking each other with their front hooves in a boxing match.*

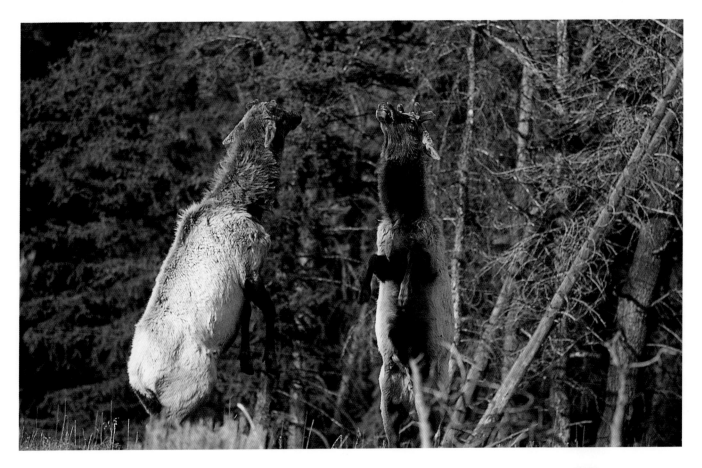

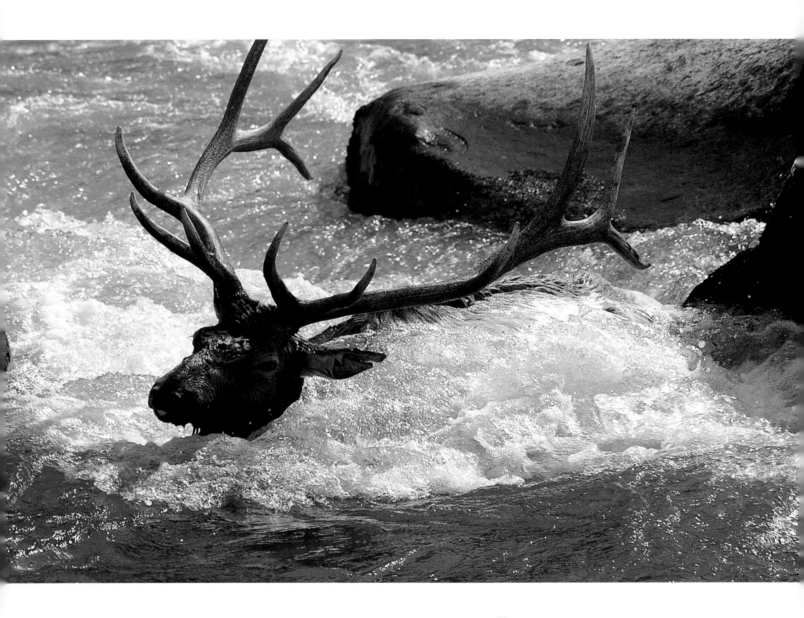

ABOVE: *Everyday in Yellowstone there are life and death struggles. One day my wife and I witnessed one of those struggles. Attempting to cross the Yellowstone River, this bull elk was swept downstream and became wedged between boulders, unable to escape. In less than a half-hour, this magnificent bull drowned in front of us.*

FACING PAGE: *Spring runoff is a powerful force. Here the turbulent runoff roars through the Lamar River Canyon.*

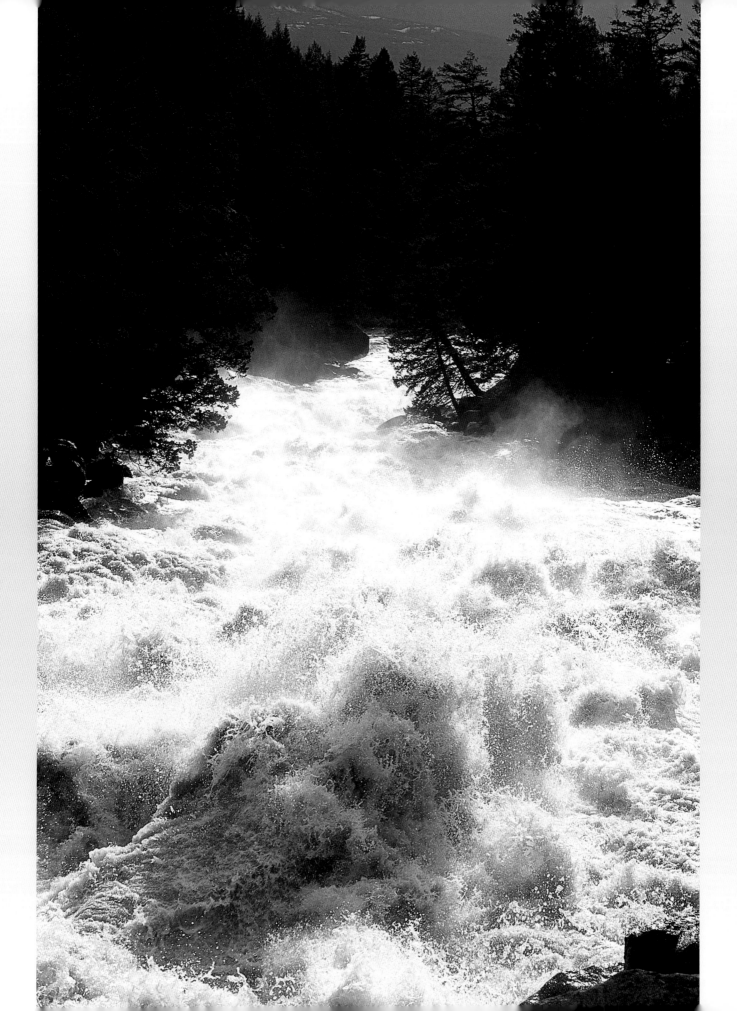

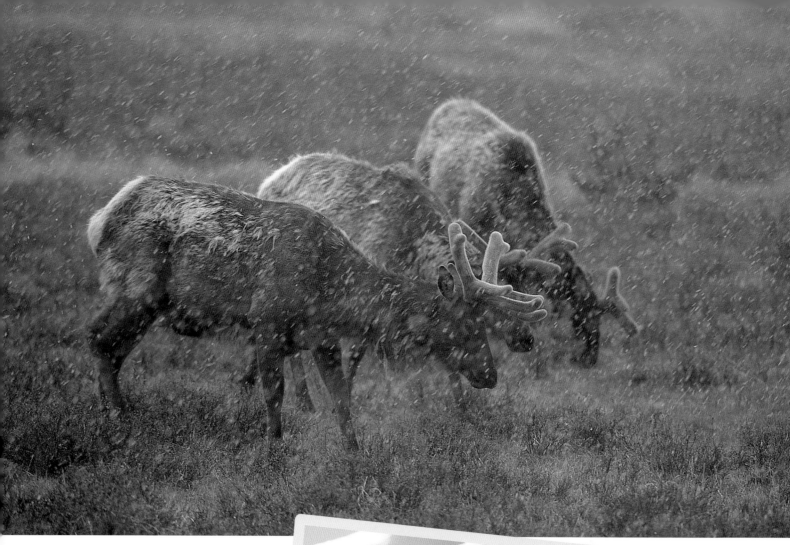

ABOVE: *A spring snowstorm doesn't faze these bull elk feeding on new plant growth. They need the forage to recover from winter, grow their summer coats, and nourish those new antlers.*

RIGHT: *A snowshoe hare in its winter coat would be hard for a predator to spot.*

FACING PAGE: *This is a "ghost tree." It forms in bitter cold when steam from a thermal area drifts across the branches and freezes. A little snow helps, too.*

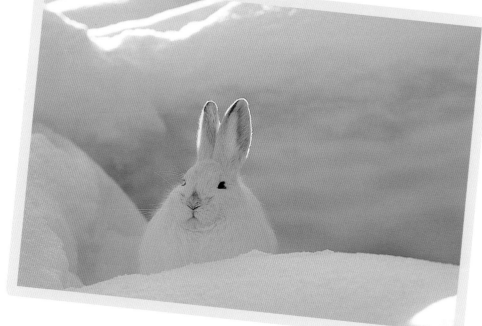

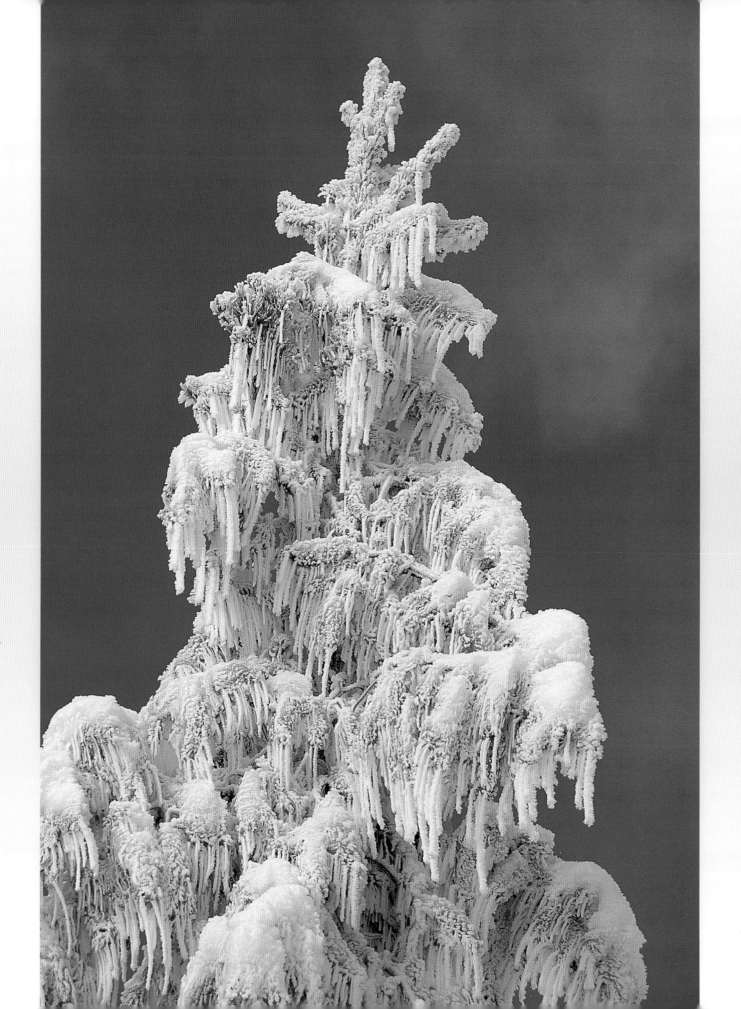

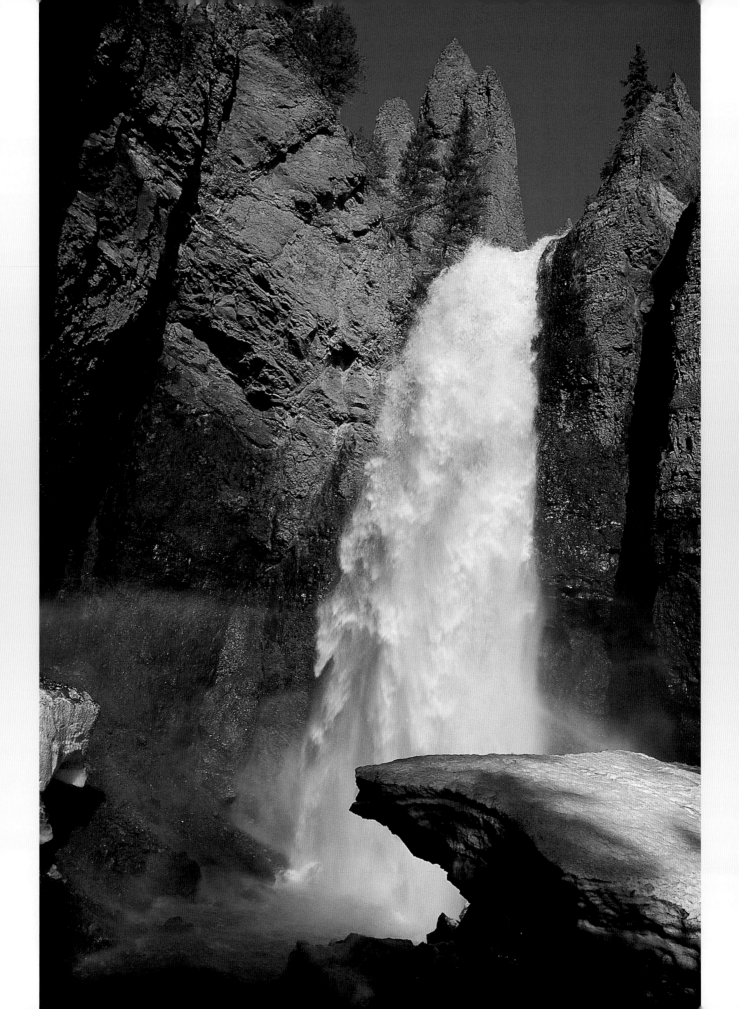

# Red fox memories

The red fox is the shyest of the park's three canids. In my thirty years here I have seen red fox only a handful of times. That doesn't mean they aren't here; they are just timid. One night I was sitting in the dark at a picnic table at Slough Creek Campground. I started thinking that something was close by, watching me. I turned on my flashlight and sure enough, a red fox was sitting at the other end of the table. Not all red fox are red; some may be black, gray, or a reddish blond. But no matter the color of the body, the tip of a red fox's tail is always pure white.

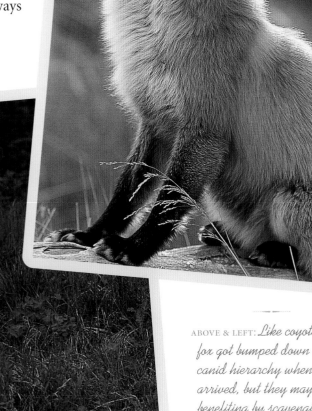

ABOVE & LEFT: *Like coyotes, red fox got bumped down the canid hierarchy when wolves arrived, but they may be benefiting by scavenging on the extra carcasses from wolf kills. The red fox at left has caught a ground squirrel.*

FACING PAGE: *Tower Falls is one of Yellowstone's prettiest waterfalls.*

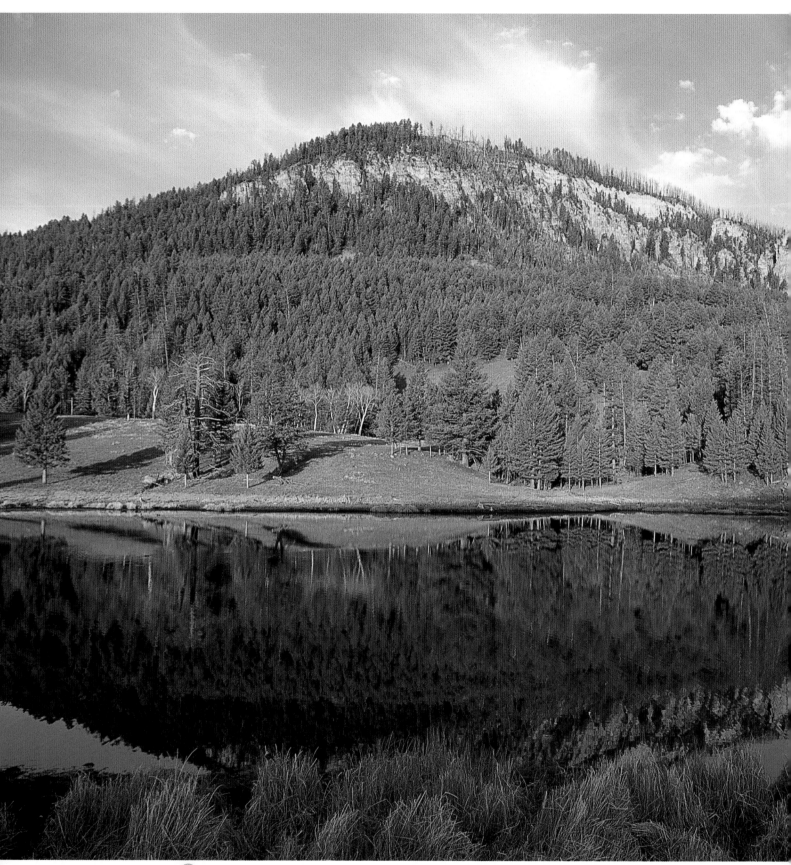

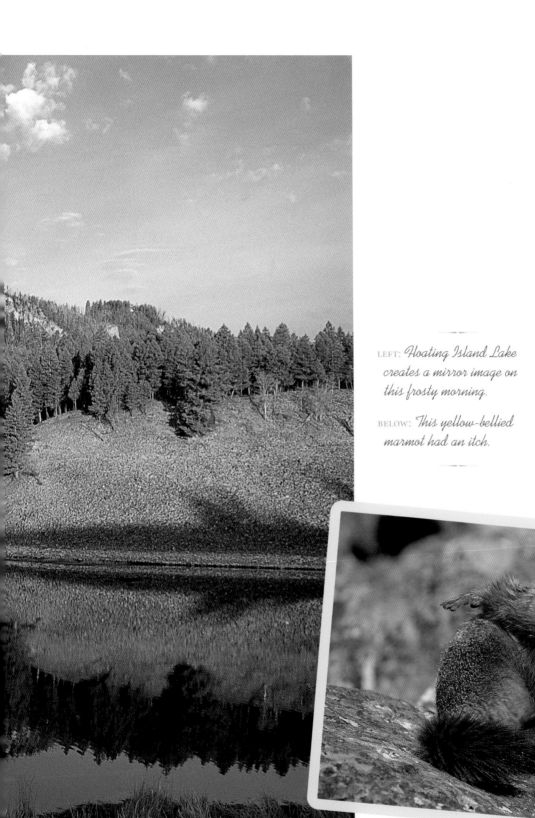

LEFT: *Floating Island Lake creates a mirror image on this frosty morning.*

BELOW: *This yellow-bellied marmot had an itch.*

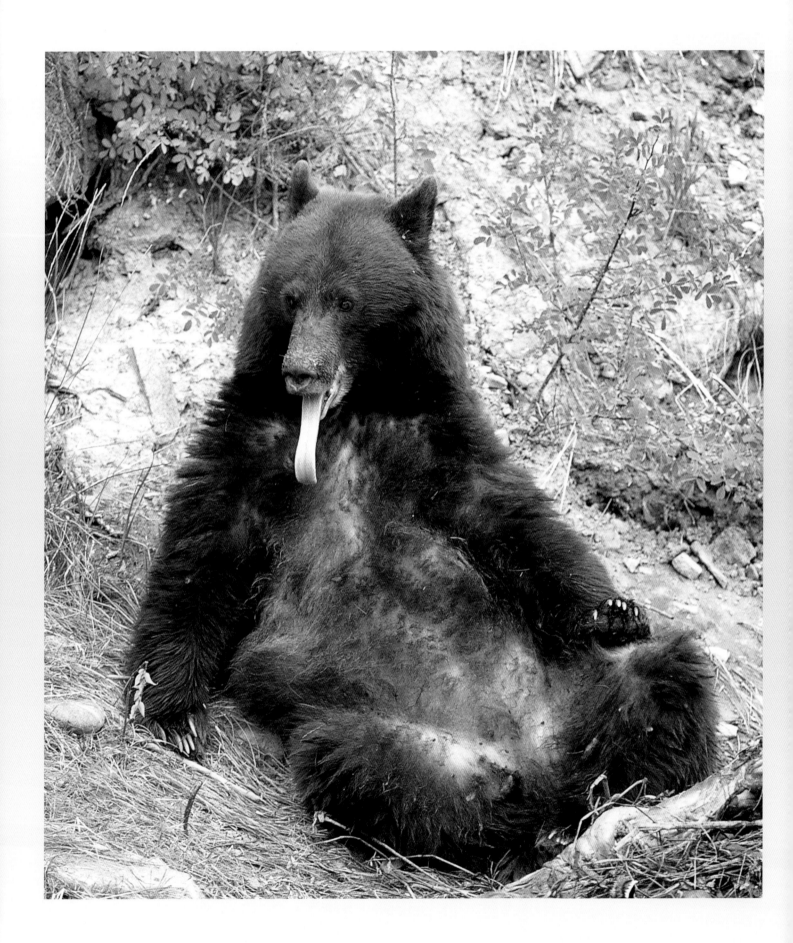

# Black bear memories

Then: When I first started working in the park, the last of the roadside-begging black bears were visible. It was not uncommon to see half a dozen of them on a trip around the park.

Now: Black bears are more commonly seen from the road than they were thirty years ago. Some days in the Roosevelt and Tower areas I see more black bears in a day than I saw in a whole season in past years.

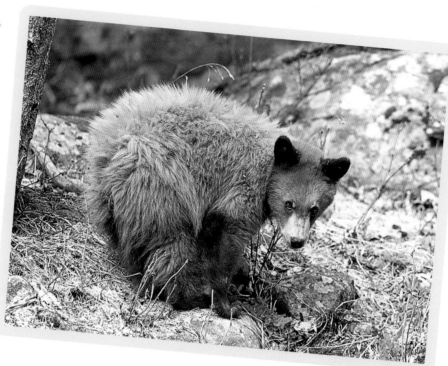

## IN THE DARK OF THE NIGHT

It really is amazing how black bears can be close by, yet for the most part remain invisible. When I was manager of Mammoth Hotel, I had my night watchmen include wildlife observations in their reports. Most evenings my guys would see at least three black bears in and around the cabin area. Some visitors ignored park rules and cooked on the cabin decks, often leaving their charcoal grills and coolers outside. Of course, during the night the bears would sniff out these offenders. Before getting the reports I would have guessed that an occasional bear passed through the area. I had no idea there was so much bear activity every night.

## A SPEED CLIMBER

In the early 1980s I often saw a special black bear that lived near Phantom Lake on the road between Mammoth and Tower. "Phantom Lake Blacky" was a very small male that hung out near the road. Once I was fortunate enough to spend most of a day observing and photographing Blacky. On this day I witnessed a behavior I had never before seen. For no apparent reason Blacky would climb up

ABOVE: A real bundle of fur, a year-old black bear feeds on vegetation. At this age and size, he has to keep watch for bigger predators, including other bears.

FACING PAGE: This brown-colored black bear just finished feeding on a carcass. Looks like she was thinking, "I can't believe I ate the whole thing."

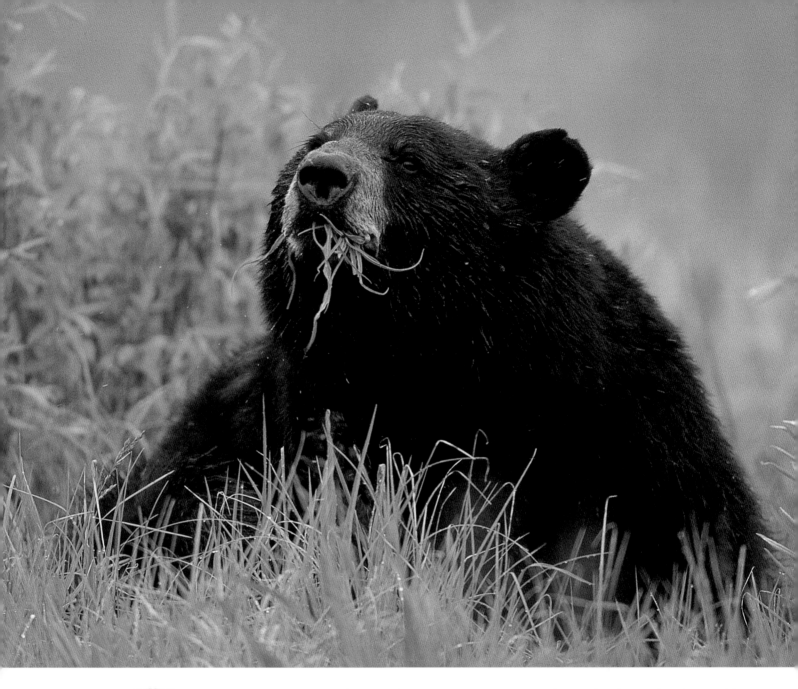

ABOVE: *Vegetation forms the bulk of a bear's diet, whether a grizzly bear or a big male black bear like this one.*

a large tree at full speed until he got to the top. Then as he descended, he would break certain branches by bouncing up and down on them. When he reached the ground, he would race up the tree again. It seemed as if the bear was making sure he had removed any branch that might slow him down as he climbed. He did this with several trees in the area. My best guess is that this small bear was preparing escape routes, probably from larger bears (both black and grizzly).

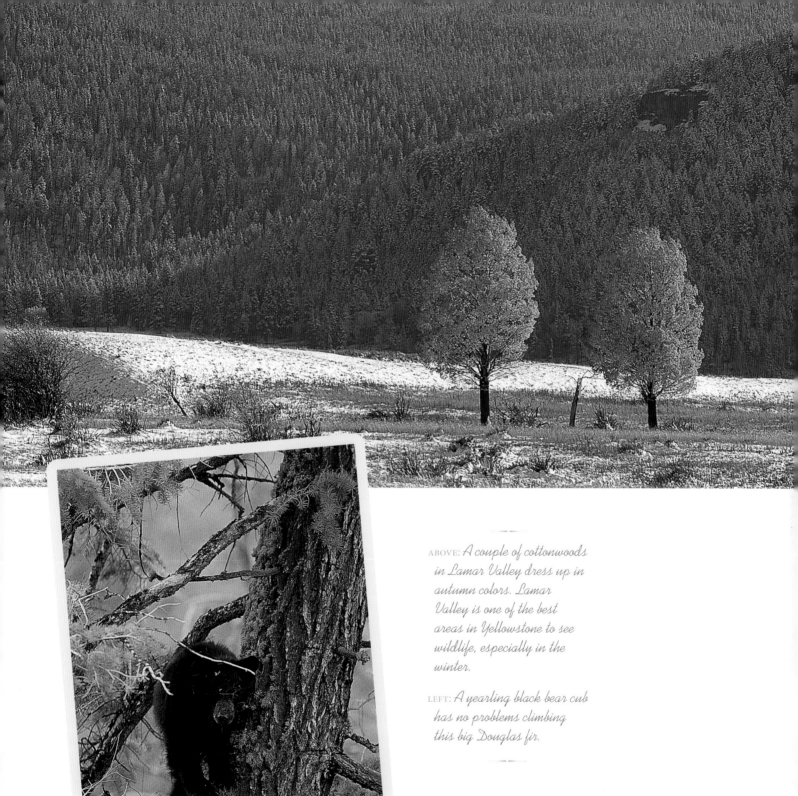

ABOVE: *A couple of cottonwoods in Lamar Valley dress up in autumn colors. Lamar Valley is one of the best areas in Yellowstone to see wildlife, especially in the winter.*

LEFT: *A yearling black bear cub has no problems climbing this big Douglas fir.*

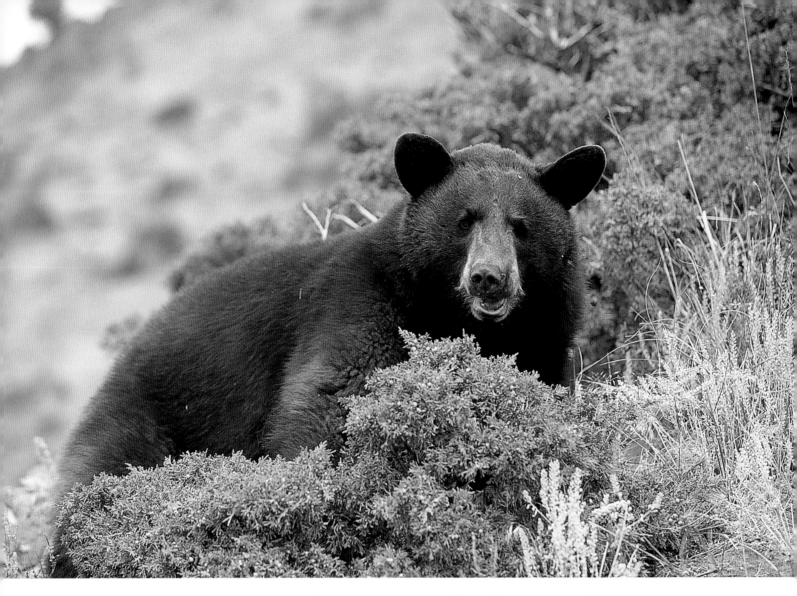

ABOVE & RIGHT: *Yellowstone's black bears aren't always black. Brown, or cinnamon, is also a common color, like the adult above and like the one-year-old cub playing with its black-colored mother at right.*

FACING PAGE: *Long a symbol of Yellowstone, the eruption of Old Faithful has been imprinted on the minds of millions of park visitors.*

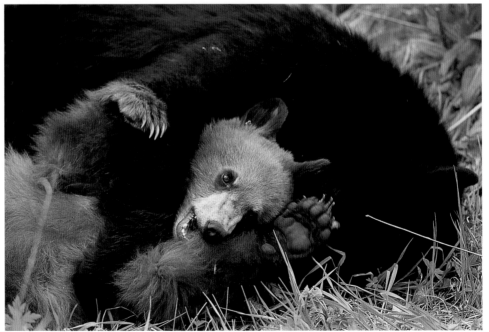

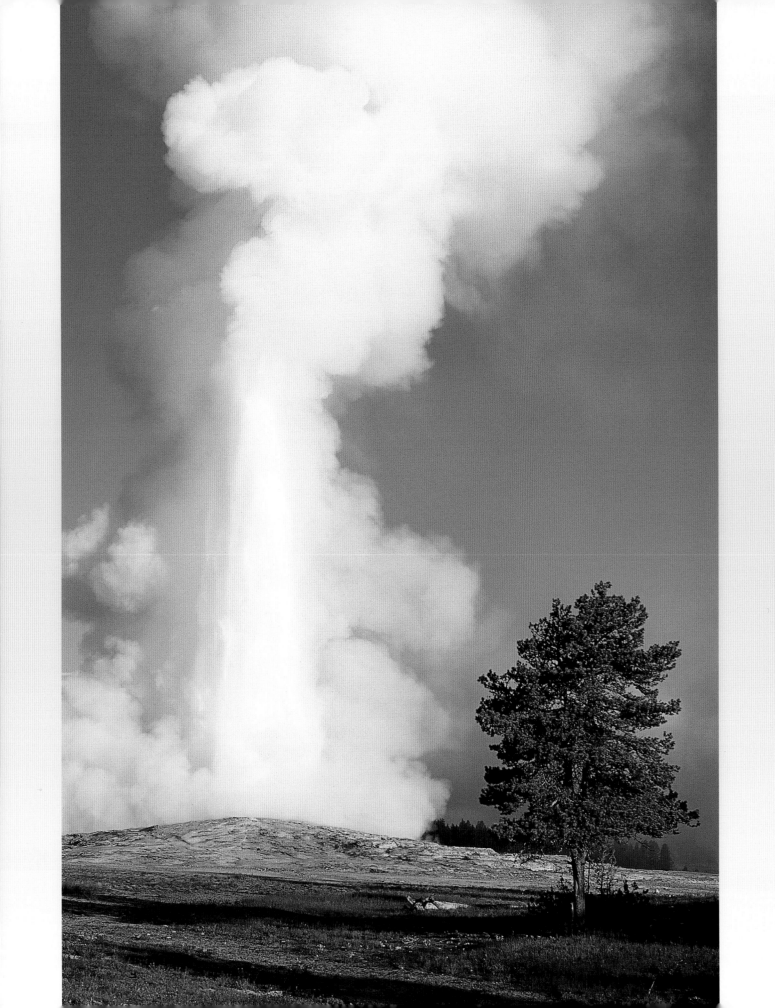

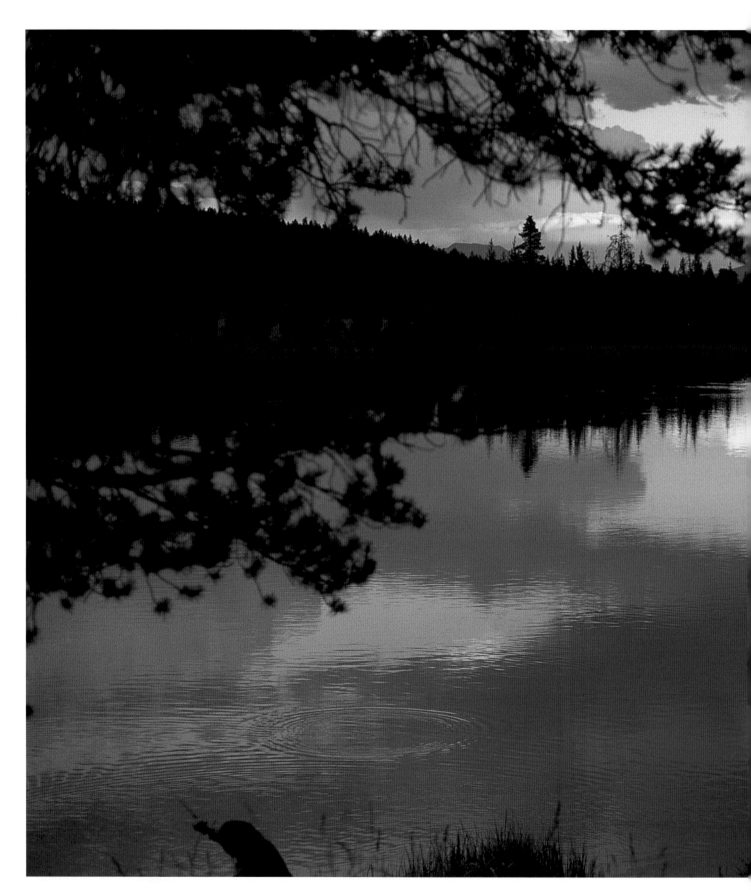

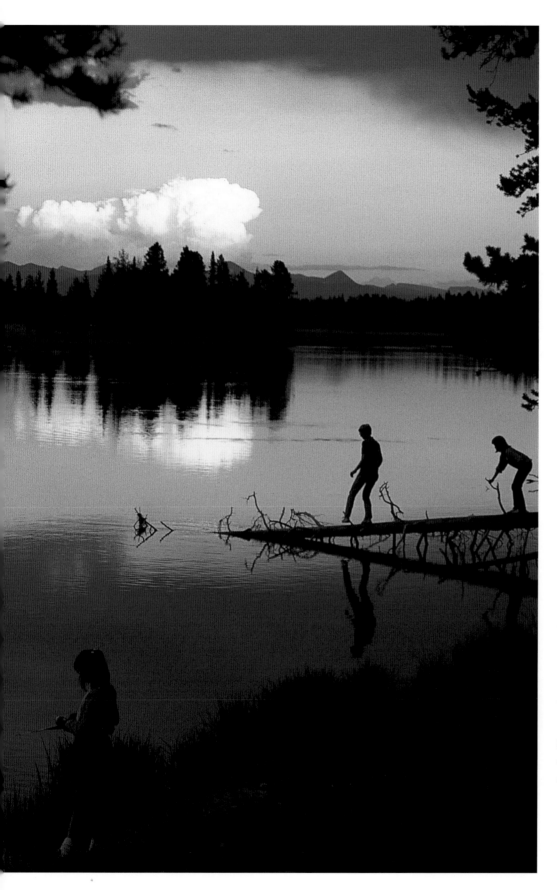

As they have done in Yellowstone for more than 100 years, some children experience nature along the Yellowstone River. One of the most surprising—and satisfying—aspects of my thirty years in Yellowstone is how little it has changed. There are wolves now, and lake trout (unfortunately) in Yellowstone Lake, and more visitors, but fundamentally Yellowstone is still the wild place it was when I first came here. I think—I hope—it always will be.

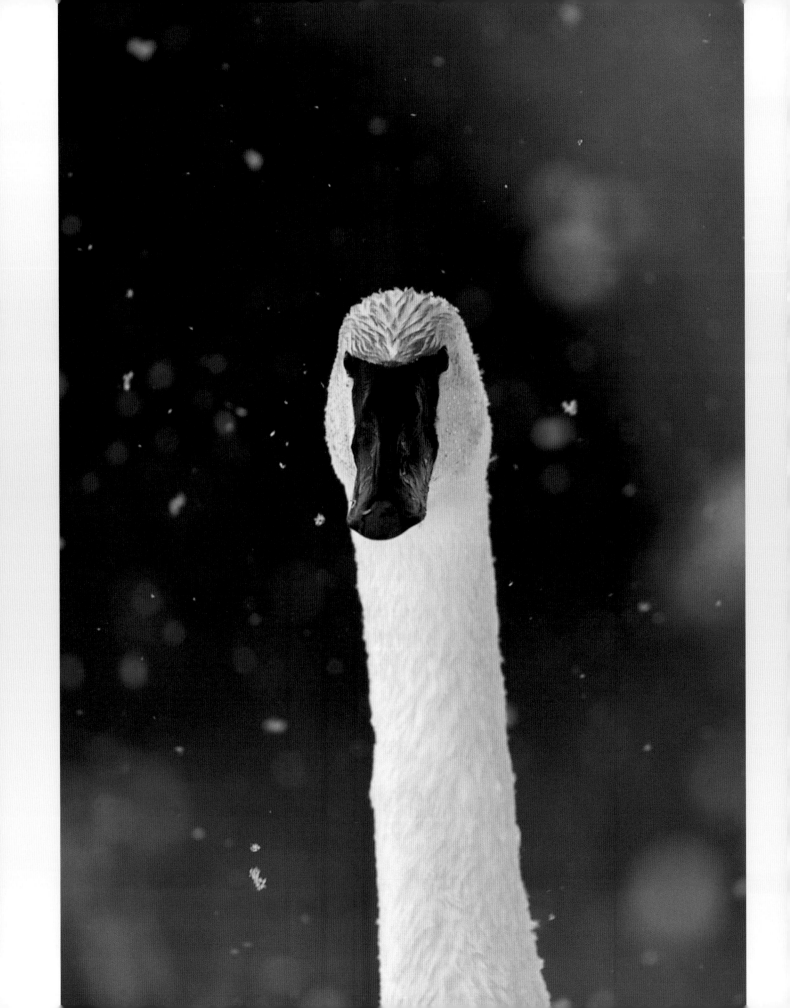

# Otter memories

The otter is one of my favorite animals. I know of no other animal that seems to have as much fun. I just wish they were visible to more park visitors. There is never a guarantee you will see an otter when you want to find one. Through the years I was fortunate to find a den site and some resting areas where I could see otters with some regularity. I've seen them mating. I've seen them sneak up and capture ducks, pulling them under water and drowning them. One day I saw an otter regurgitate a ball of parasites. Being scientifically minded, I collected them and took them to a parasitologist to study.

While working at Lake Lodge I found a spot along the Yellowstone River where a family of otters spent considerable time. How did I know they spent time there? Lots of scat piles that were mostly fish scales! One day I found out how quiet and secretive otters can be. As I was walking on a large hollow log that protruded into the water, I heard a slight gurgle and watched as several otters came out of a hole in the log and slid into the water with hardly a sound.

*Yellowstone's rivers and lakes are wonderful places for wildlife. Otters (an adult and nearly grown pup, above) always make me smile. An osprey plucks a fish from the Madison River (left), and a trumpeter swan (facing page) surveys its surroundings on a snowy day.*

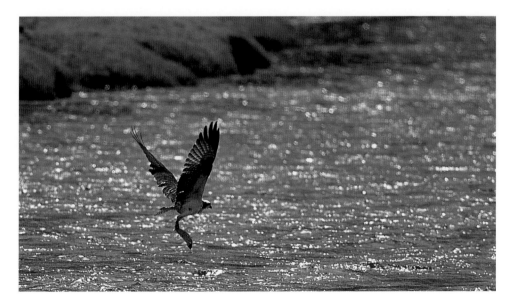

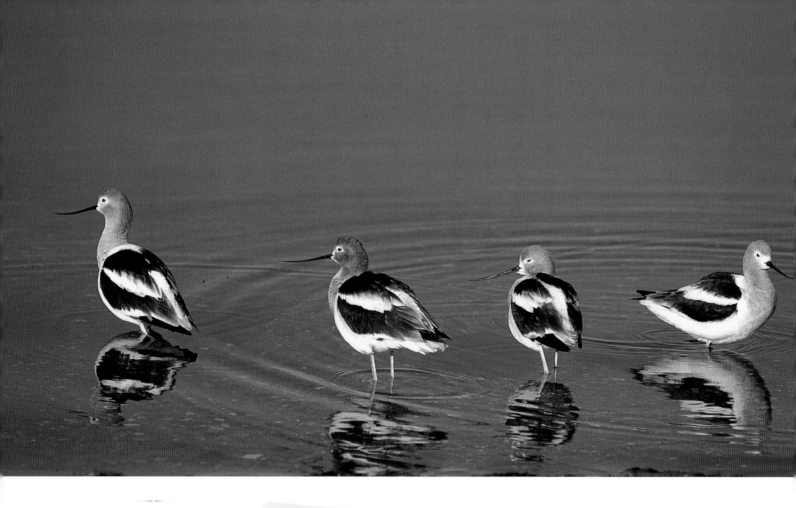

ABOVE: *American avocets wade the shore of Yellowstone Lake.*

RIGHT: *A beaver nibbles on a plant.*

FACING PAGE: *I've seen more bald eagles in Yellowstone in recent years than I did thirty years ago, partly because eagle populations everywhere have recovered after the banning of the pesticide DDT and partly because wolf predation in the park has created more carcasses for the eagles to feed on.*

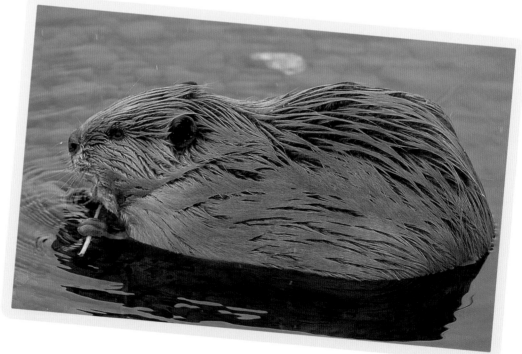

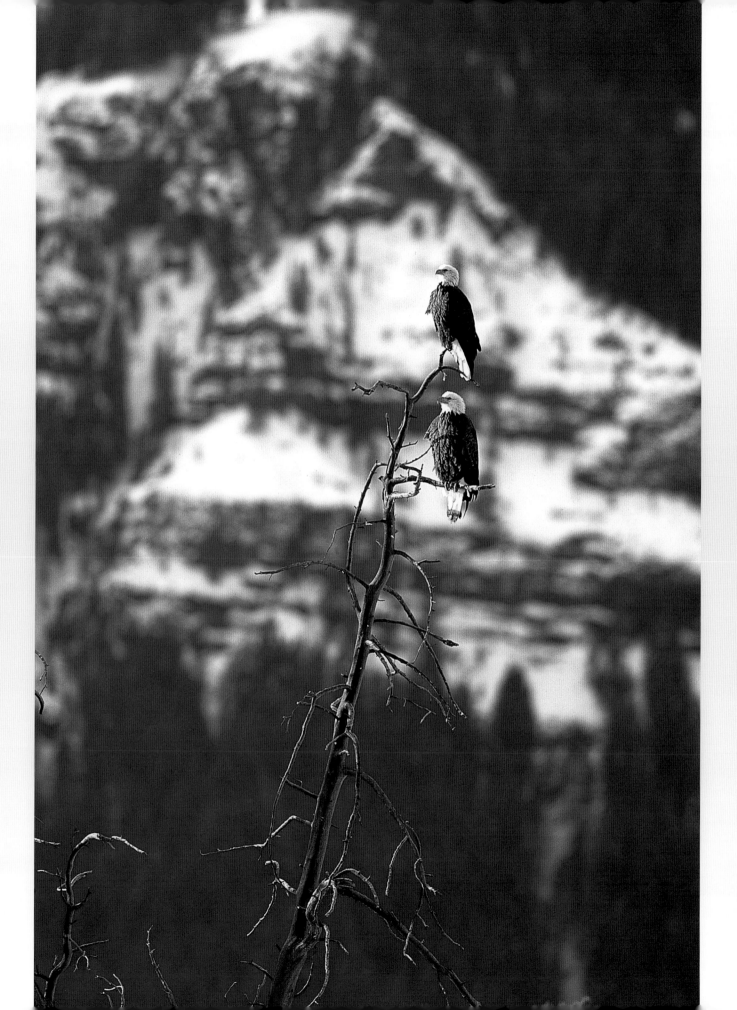

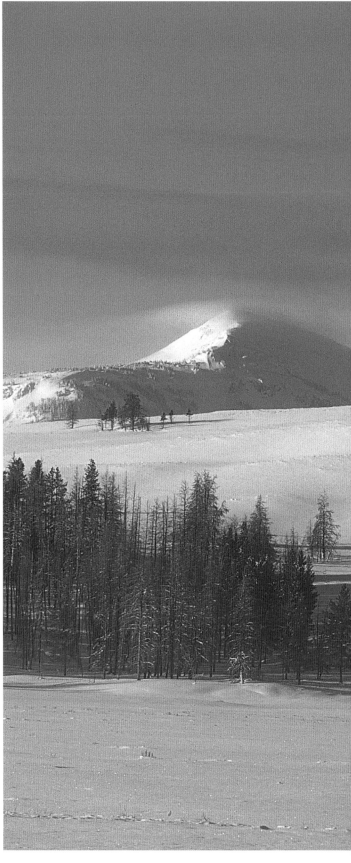

Winter has always been
beautiful in Yellowstone.
These days it is becoming more
popular for snowshoers
(below), cross-country skiers,
and wildlife watchers. From
left to right in the landscape
at right are Trilobite Point,
Mount Holmes, and Dome
Mountain.

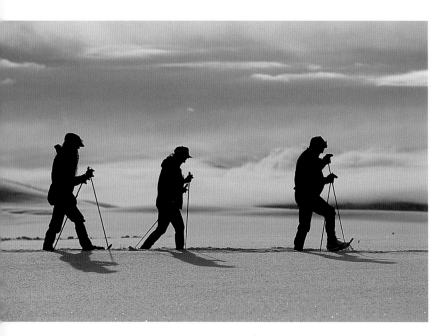

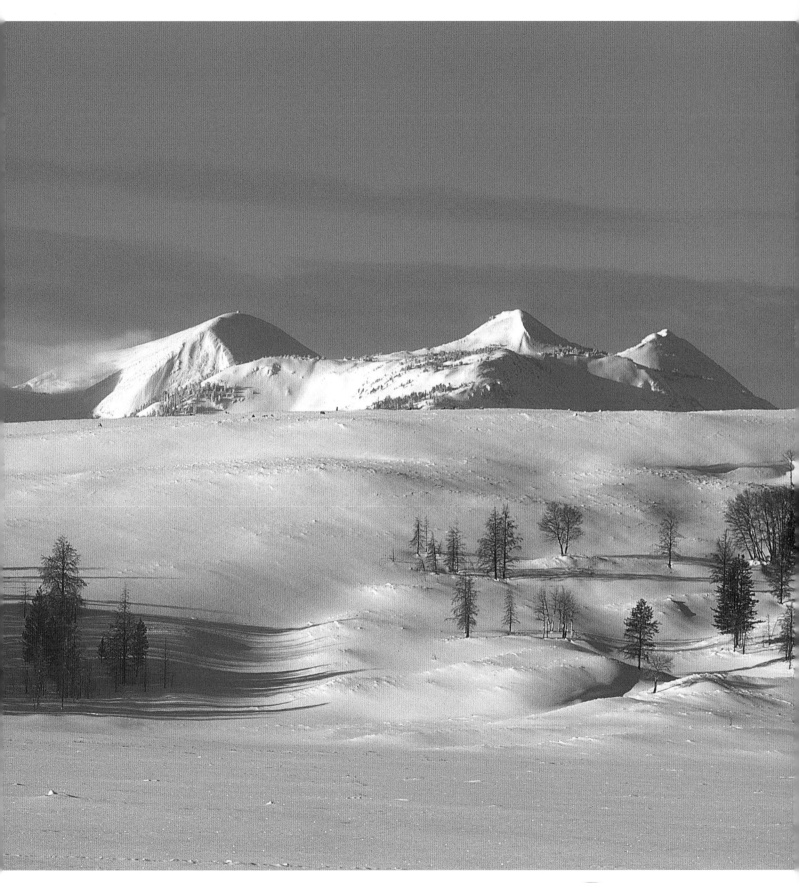

Aptly named Orange Spring Mound is my favorite thermal feature in the Mammoth Hot Springs area. Thought to be very old, we know it has changed very little in more than 100 years of photography. The orange cyanobacteria that cover the mound are the origins for its name; the color looks a little different each year depending on water flow and the amount of sunlight.

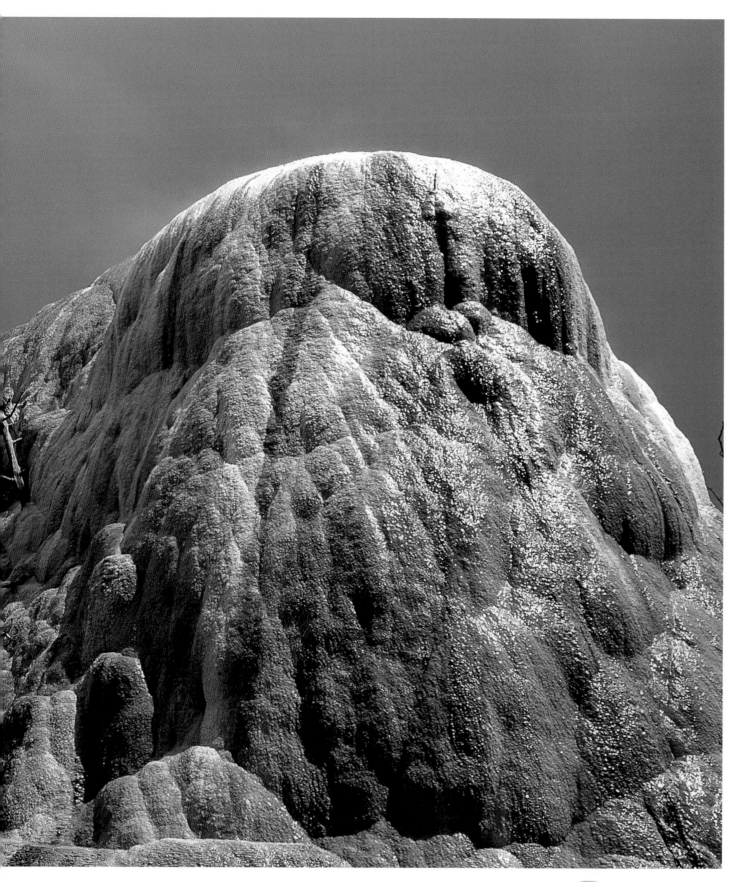

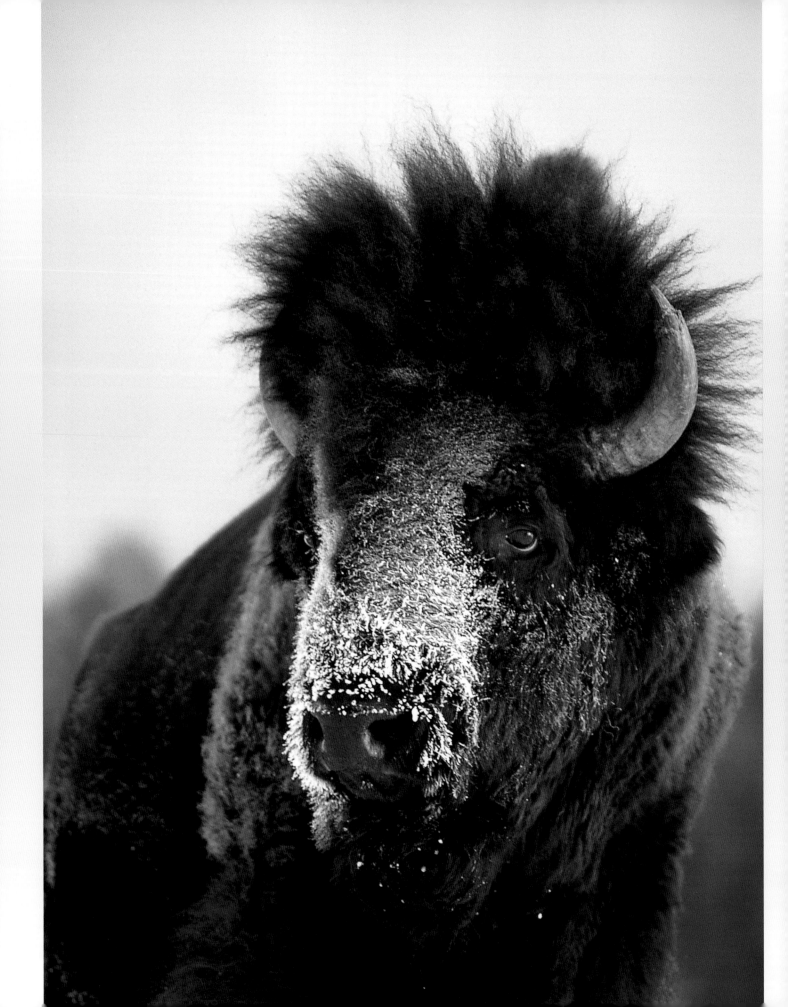

# Bison memories

Then:  When I first came to the park there were bison, of course, but their numbers were only in the hundreds and they were not always visible from the road. Herds frequented Hayden Valley and lone bulls could be found in front of Lake Lodge. A handful of bulls wintered along Soda Butte Creek in Lamar Valley.

Now:  The bison population has exploded to more than four thousand animals. Numbers are so high I'm worried other wildlife may be impacted. The Pelican Creek area that had so many moose in the late 1970s no longer has willow growing in it since bison started wintering there. I had hoped that wolf predation would help control the bison population, but so far wolves are having little effect.

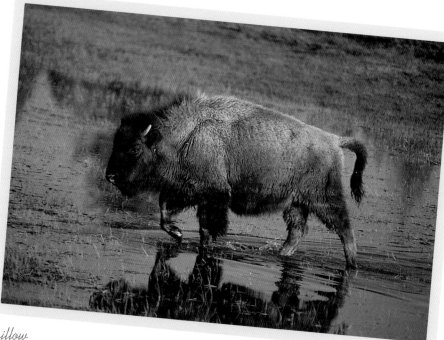

ABOVE: A yearling bison plods through a flooded meadow.

FACING PAGE: The hair on this bison was standing out because of static electricity after wallowing in the snow. He certainly looks different.

## GIVING BISON A WIDE BERTH

Bison are big. Bison are unpredictable. Since I've been in the park, bison have injured many more people than bears. Some park visitors seem to think bison are like docile cows in a pasture. Of all the park animals, I give bison the widest berth. I'll even change hiking plans if too many bison are on the trail I want to take.

Once I thought I was going to photograph the death of a fellow human by a bison. I was photographing in Hayden Valley when a pickup truck with Texas license plates stopped. A cowboy got out and walked up to a large herd bull that was lying in the sagebrush. The man approached within a few feet. The bull got up and started pawing the ground, sending the dirt flying. The cowboy just laughed, reached out and petted the bull on its head. Even though my camera was mounted on a tripod, I could hardly keep it steady because I was shaking so badly. I thought a horn would be going through the guy's chest at any moment. The man turned his back on the bull, waved to his buddy in the truck, and walked back. The bull just stood there, thinking, I'm sure, what an idiot!

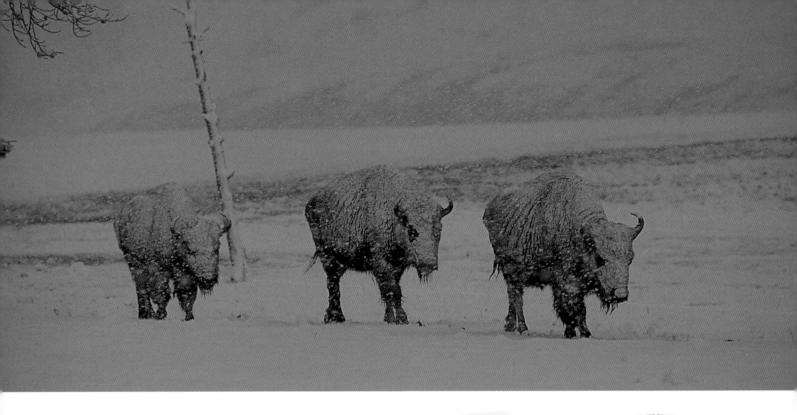

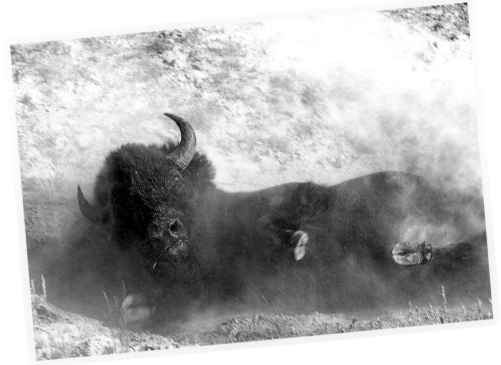

## THROUGH THE ICE

One winter I saw a group of cow bison walking across the frozen Yellowstone River. One cow fell through the ice and could not pull herself out. After about forty minutes of swimming around in a small circle, her head eventually went under and she drowned. Later I learned that almost every winter a number of bison drown in that area, and in the spring grizzly bears feast on the carcasses that wash ashore.

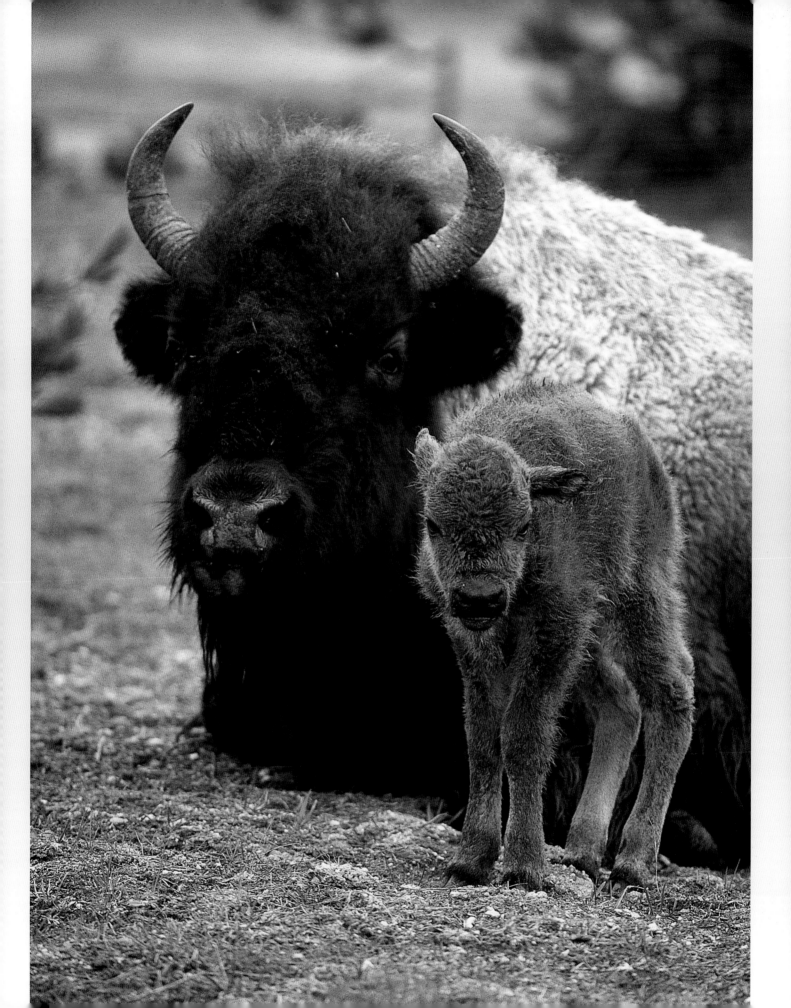

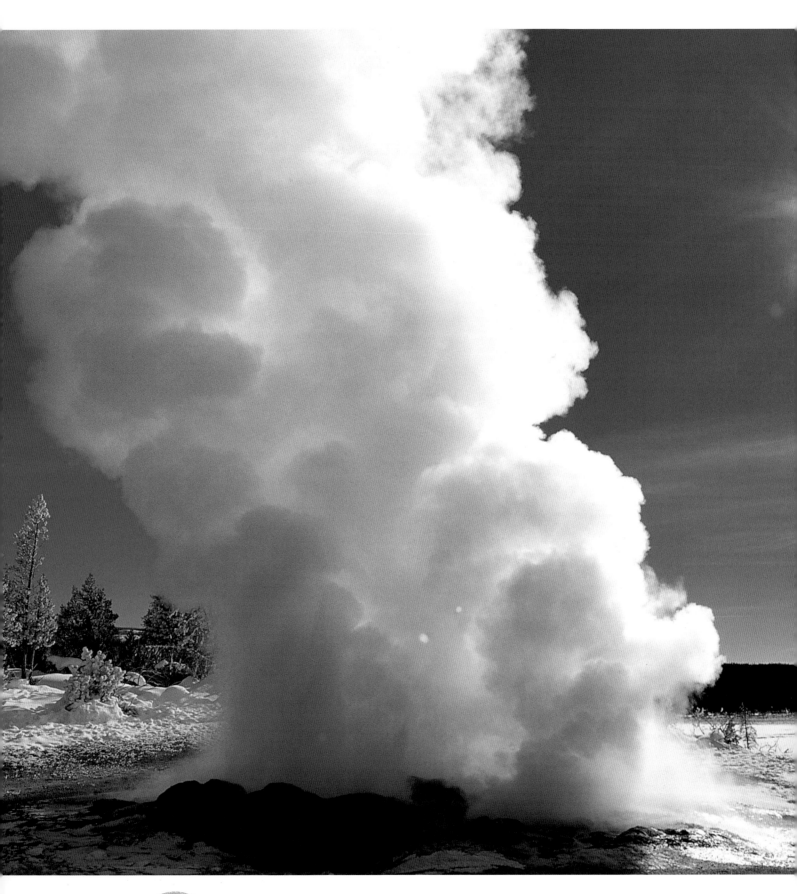

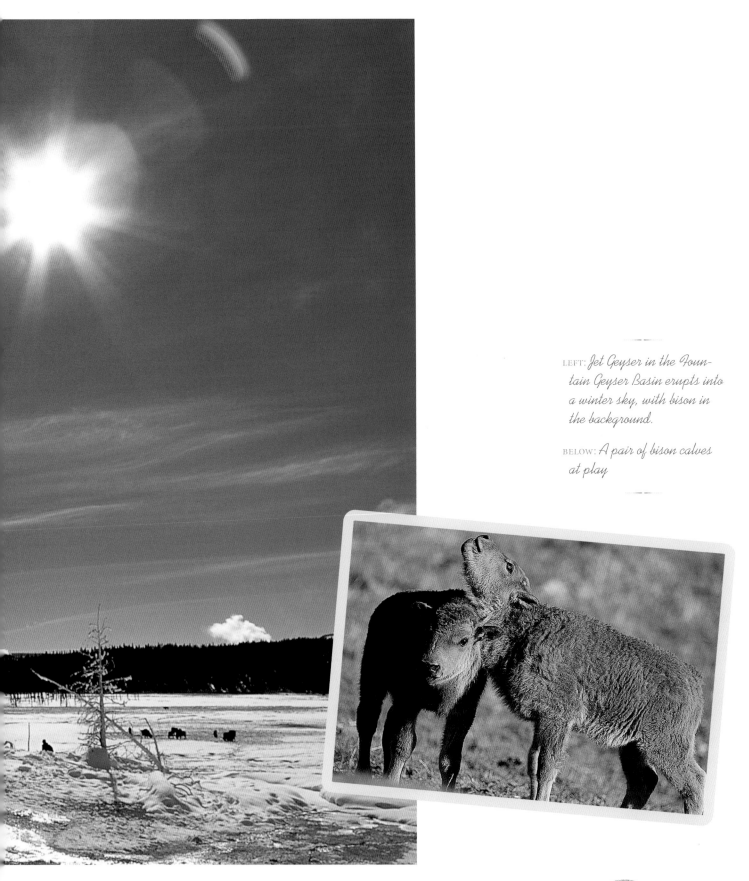

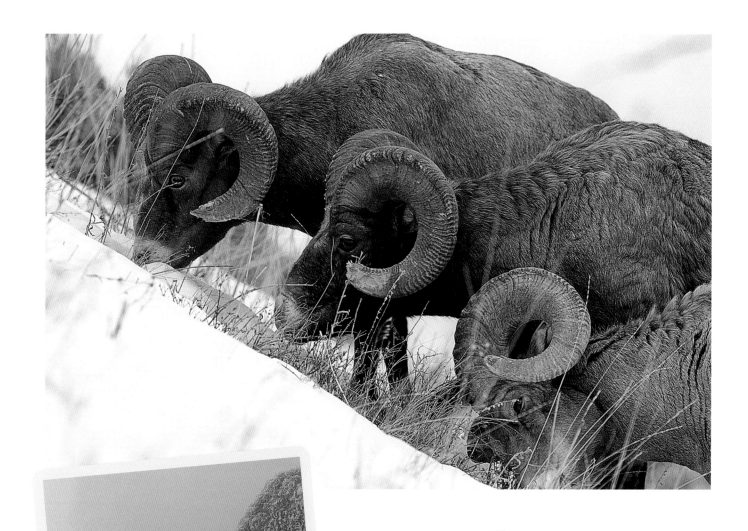

ABOVE: *A trio of male bighorn sheep feeds on a wind-swept hillside. Rams form bachelor groups for the bulk of the year. It is only during the fall rut that they battle each other for breeding rights. Between rams of equal size, these head-to-head clashes can go on for hours.*

LEFT: *Frost covers a large bull bison in the Biscuit Basin thermal area after a night when the temperature dropped to fifteen degrees below zero. In the winter some bison utilize thermal areas for warmth and for grazing because there is less snow on the heated ground.*

FACING PAGE: *A big snow-covered bull elk bugles during the late September rutting season.*

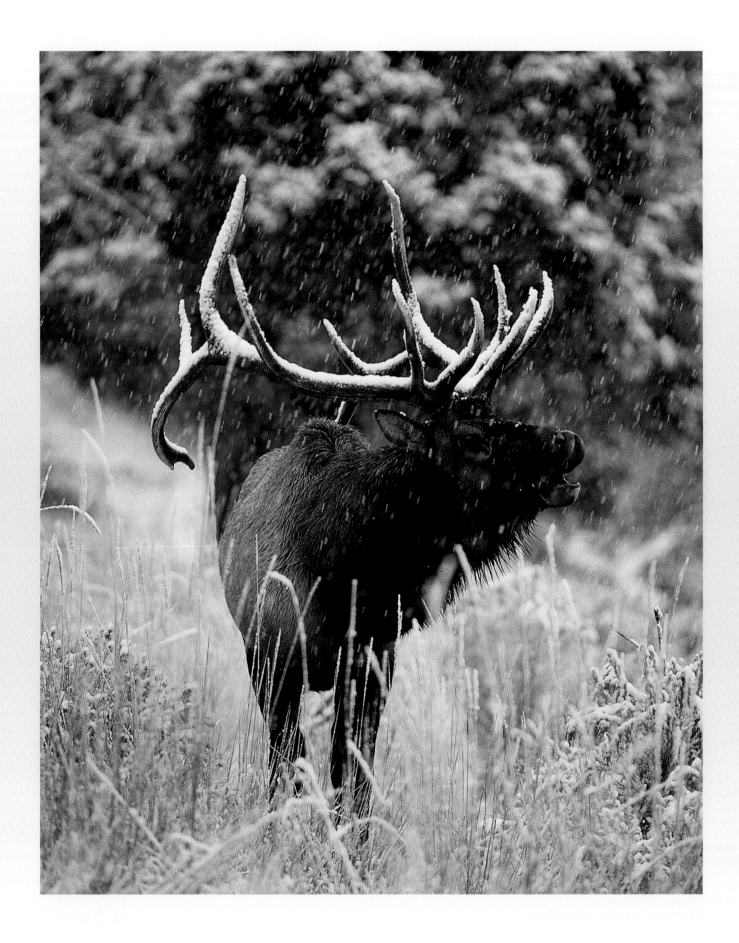

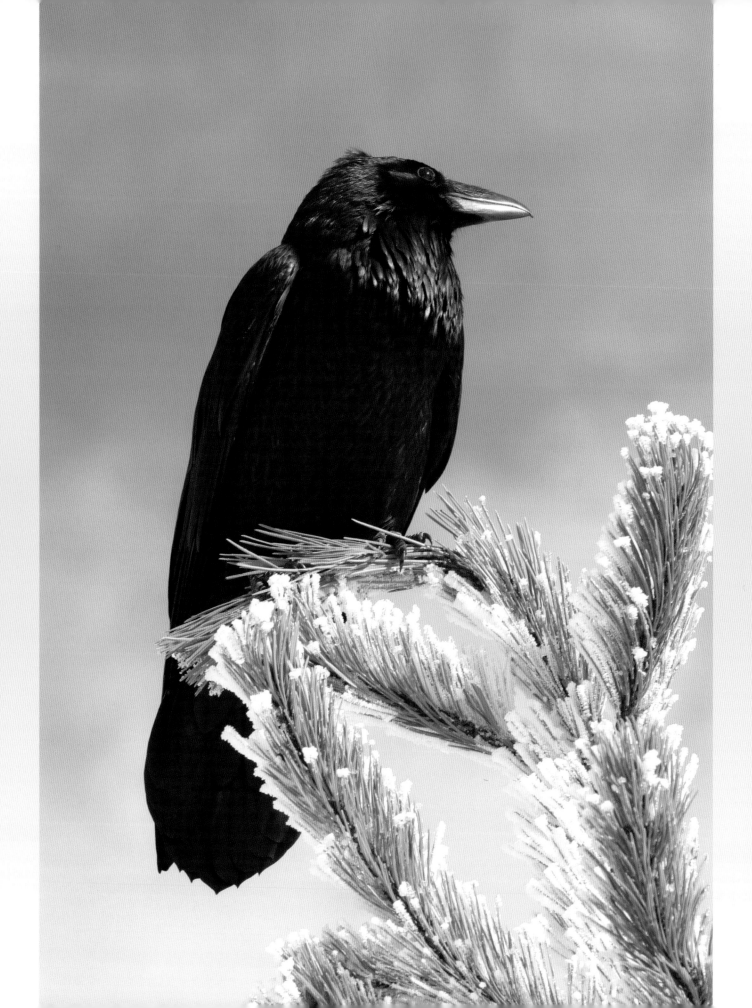

# Raven memories

Ravens are very common birds in Yellowstone, and they are smart. Once I watched a raven play a practical joke on a cabin maid at Lake Lodge. The maid had all her supplies on a cart that she wheeled from cabin to cabin. As she was inside a cabin, the raven swooped down and landed on her cart. The raven grabbed soaps, washcloths, and other small items and dropped them on the ground. Then it flew to a rooftop and waited for the maid to return. When she saw the mess and looked around for the culprit, the raven called out in what I can only describe as a human-like laugh.

Ravens have learned that snowmobiles carry food. I have watched ravens open snowmobile compartments that were sealed with Velcro, zippers, and snaps. One time I watched a raven pull a wallet out of a pack. I had to laugh as the owner came back to find his dollar bills floating in the air.

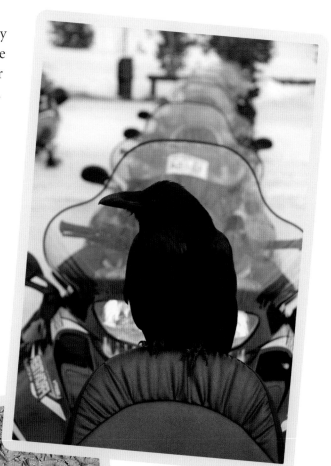

ABOVE & FACING PAGE: *Ravens are very common birds in the park. They nest in trees or cliffs beginning in March or April. Early in the morning the pairs are often found sitting together on tree branches.*

LEFT: *Each time you visit a mud pot it will look different depending on the amount of water bubbling up through the mud. This is Artist's Paint Pot.*

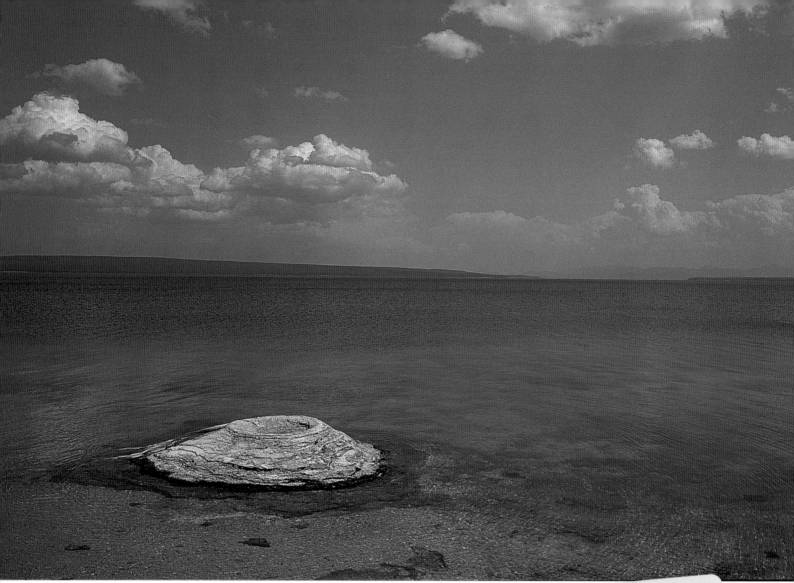

ABOVE: *Early day fishermen at West Thumb Geyser Basin on Yellowstone Lake made Fishing Cone famous. They would stand on the cone, cast out line, catch a cutthroat trout, and lower it into the hot water of the cone to be cooked—all without taking the fish off the line. This practice is no longer allowed because of the delicate nature of thermal features.*

RIGHT: *A mature bighorn sheep runs along a hilltop.*

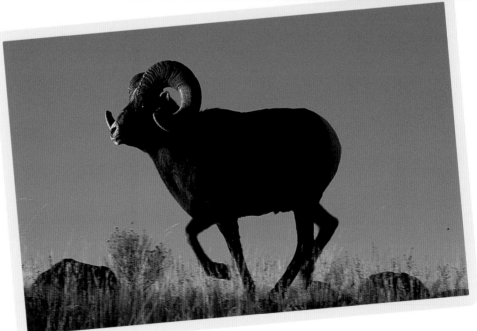

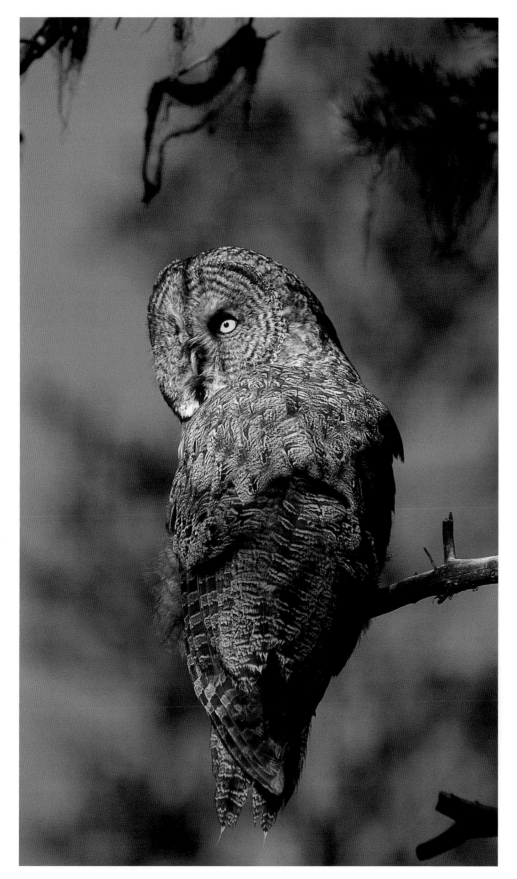

Great gray owls are my favorite owls in the park. These large owls are difficult to spot because they are generally quiet and blend into the forest. Once found, however, they are very tolerant of visitors and for the most part will ignore your presence. How do you know you are looking at a great gray owl? Look for the white "bow tie," a white patch on the throat. Since the Fires of 1988 I have had a hard time locating these owls because many of my favorite viewing areas were burned. The area around Canyon Village remains productive.

RIGHT: *I suppose it looks somewhat like its name, Thermos Bottle Geyser. It's in Monument Geyser Basin.*

BELOW: *One of the most beautiful birds in the park, a male mountain bluebird.*

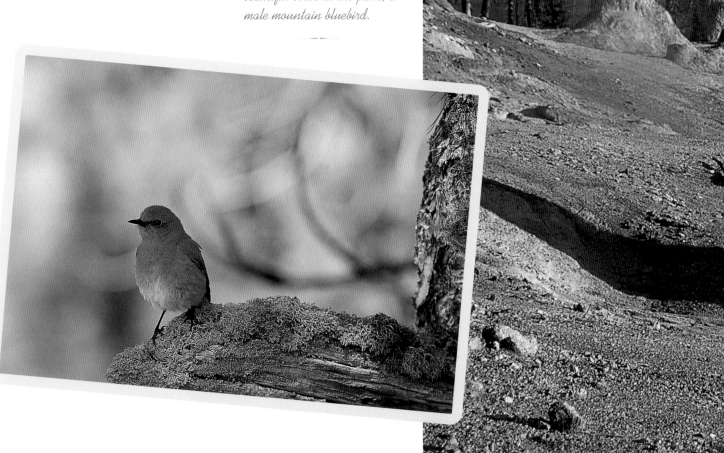

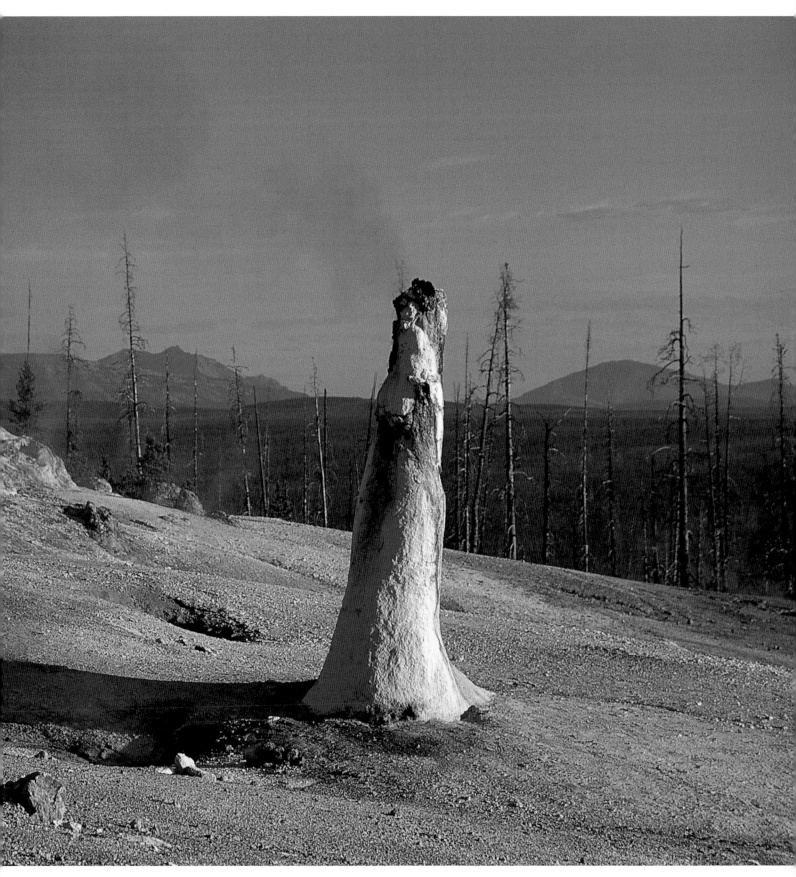

RIGHT: *Snow-draped Mount Washburn emerges above early morning fog.*

BELOW: *Shooting stars.*

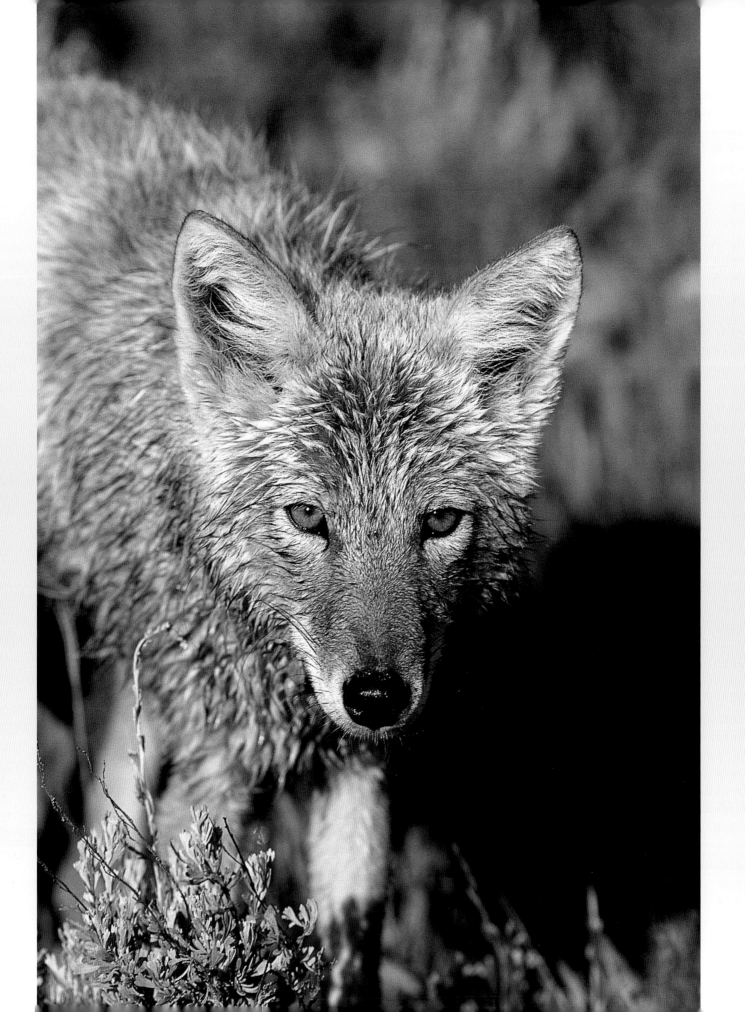

# Coyote memories

*Then and Now:    I really admire these park animals for their ability to adapt to any situation. Nothing goes on in their territory that they don't know about. If you don't believe me, just watch them for a few hours. Coyotes have led me to carcasses, bear cubs, and badgers.*

*Even with the re-introduction of wolves (and many wolf packs have become proficient at killing coyotes), coyotes are still thriving. Their numbers may be down slightly but you would hardly know it. In fact, coyotes seem to be more visible than they were thirty years ago. Perhaps they are utilizing more roadside habitat in order to avoid wolves, which tend to stay away from roads.*

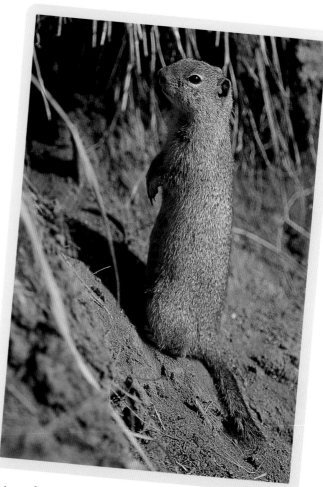

## TAKING ON A GRIZZLY

One spring day in Hayden Valley I witnessed two coyotes attempting to separate a young grizzly cub from its mother. Luckily for the bears, the mother had only one cub and was up against only two coyotes. The coyotes were constantly circling and nipping at her, trying to grab the cub. She sheltered the cub between her legs and lashed at the coyotes with her front claws. Finally the grizzly managed to get her cub up a single lone tree and then she chased the coyotes away.

## NOISES IN THE NIGHT

One evening after dark an employee came to me and said she thought someone was throwing up next to a building. It was January and I didn't want someone freezing to death, so I went outside to investigate. I found several coyotes in the process of suffocating a mule deer doe. Its final sounds resembled the sound of water gurgling down a pipe.

ABOVE: *Ground squirrels are a favorite food of coyotes, fox, badgers, hawks, and eagles. Grizzly bears will excavate large areas of ground as they dig for these tasty morsels.*

FACING PAGE: *The coyote, also known as the "trickster" by Native Americans, is a favorite of mine. Nothing goes on in their territories that they don't know about.*

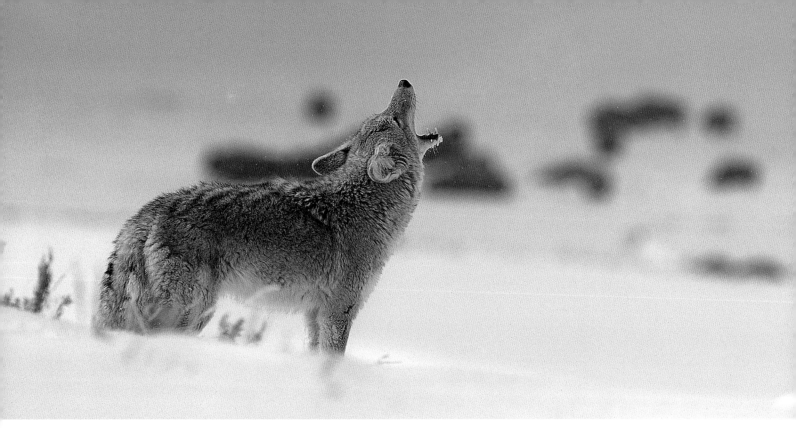

## TURNING THE TABLES ON A WOLF

Just because wolves are larger than coyotes doesn't mean they always have the upper hand. I once watched a large black wolf in Lamar Valley chase three coyotes. The coyotes took turns being chased. As one coyote got tired, another would dash in and the wolf would chase it. Eventually that wolf had his tongue hanging out from all that chasing. Then I started seeing more coyotes. Apparently the coyotes were headed to a carcass. The wolf must have smelled the carcass and made a beeline for it. Imagine his surprise when more than fifteen coyotes suddenly appeared and started chasing him. That wolf ran away with his tail between his legs and did not look back for quite some time.

*ABOVE: A coyote howls to fellow pack members in Hayden Valley. In the winter coyotes survive by hunting small rodents under the snow, but they also keep a close watch on the big animals. One large bison or elk carcass equates to many mice.*

*RIGHT: A pair of coyotes seem to be excited and agitated, perhaps at the prospect of a coming meal. A wounded elk and three wolves were nearby. If the wolves later killed the elk, the coyotes probably scavenged a meal from the carcass. Each coyote wears a radio collar as part of a scientific study.*

*FACING PAGE: Yellowstone's weather can be as wild as the landscape. Here is a combination sunset and storm over Yellowstone Lake.*

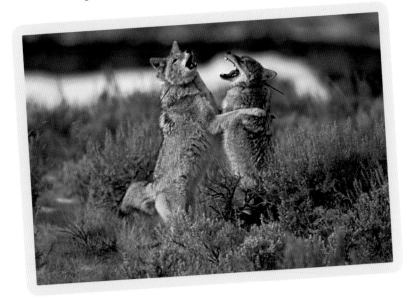

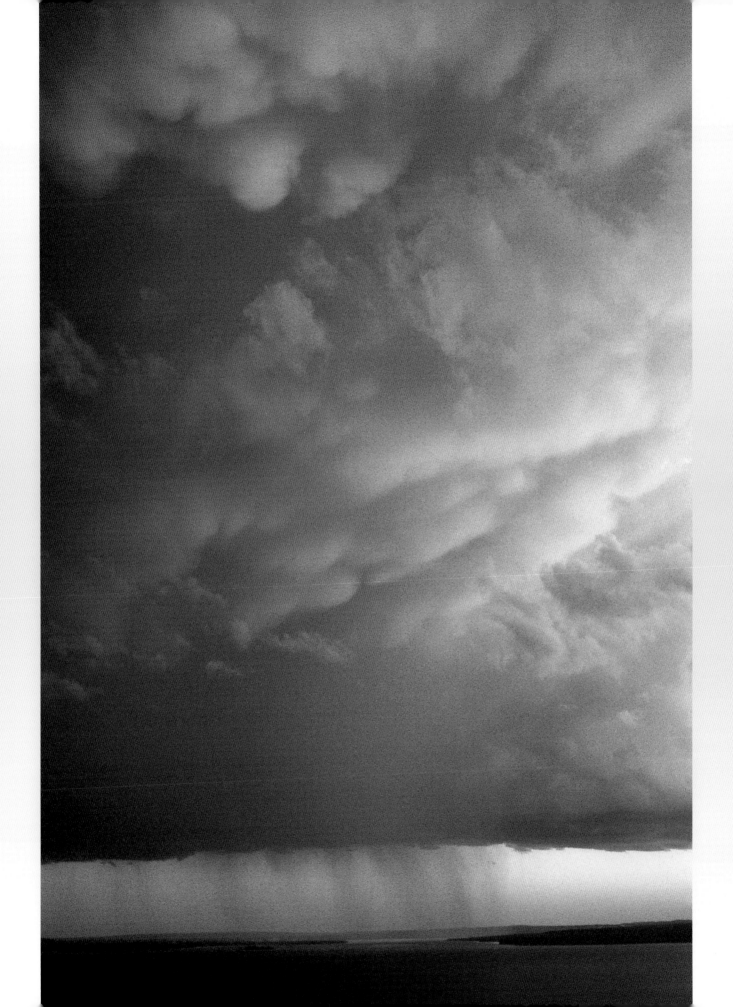

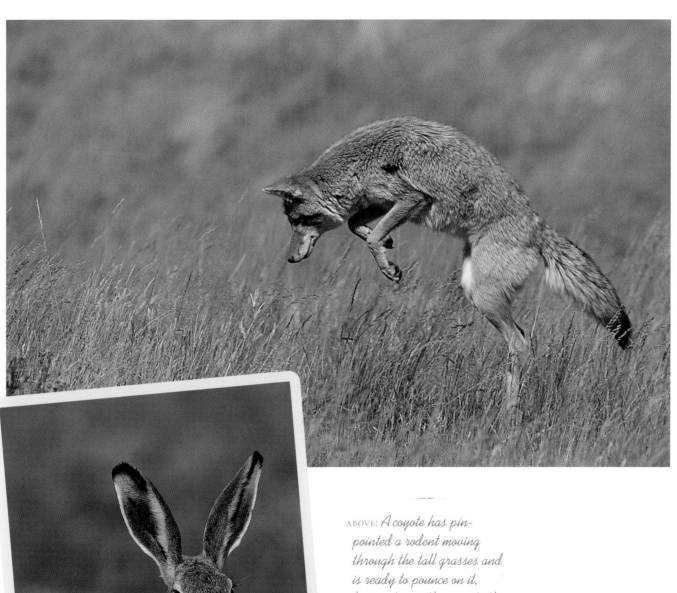

ABOVE: *A coyote has pin-pointed a rodent moving through the tall grasses and is ready to pounce on it, hoping to pin the prey to the ground with its front paws.*

LEFT: *In Yellowstone white-tailed jackrabbits are observed most often on the flats around Gardiner. They are difficult to photo-graph because they hold still just until you get close enough for a photo and then they bolt away in a cloud of dust.*

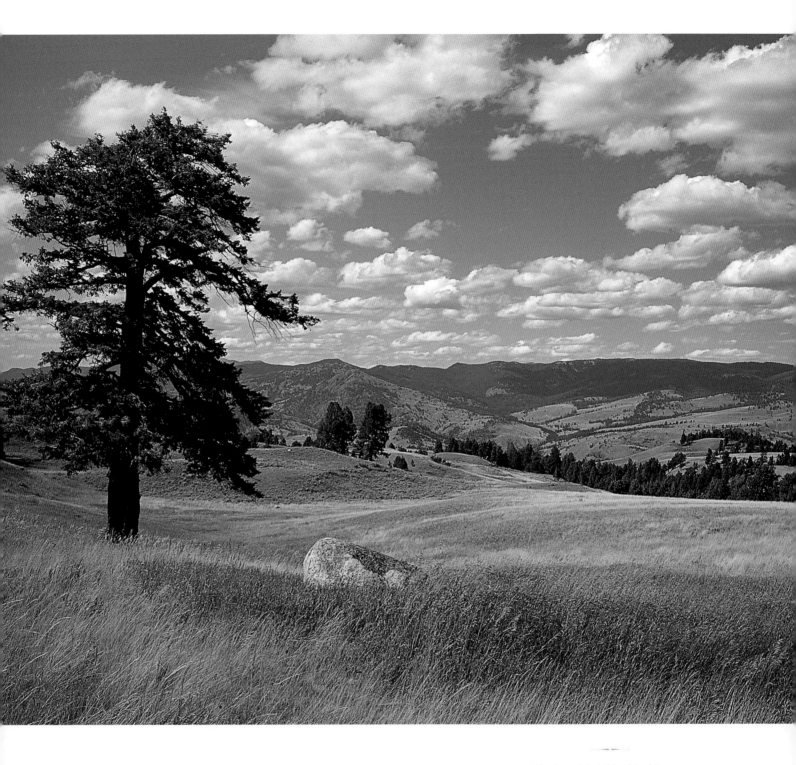

ABOVE: *The beautiful Blacktail Deer Plateau. A one-way road loops through this area. The drive is a fine way to slow down and enjoy this piece of Yellowstone, and perhaps see some wildlife.*

 *Coyote memories – 69*

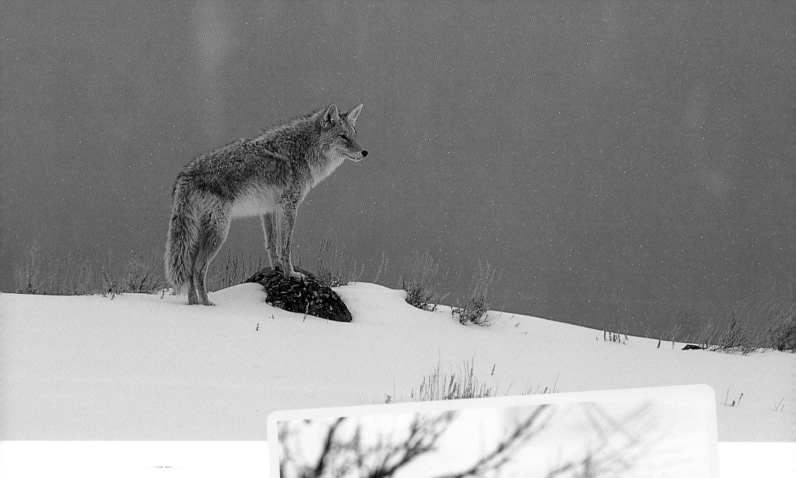

ABOVE: *Coyotes must be even more vigilant now that wolves have been added to the park. Many wolf packs have become proficient at attacking and killing coyotes, including digging up dens containing pups. Yet coyotes are more visible from the road today than they were thirty years ago. I think they are utilizing the roadside habitat that wolves generally avoid.*

FACING PAGE: *A large mule deer buck during a November snowstorm.*

ABOVE: *Some days are just lucky days. My friend Ron Shade and I were driving through Lamar Valley when we both looked at each other and said, "Did you just see a little owl on the ground in the sagebrush?" We backed up the vehicle and sure enough, there was this owl. There was a raven nearby and we thought the raven had attacked the tiny owl. Imagine our surprise when the owl finally flew off to some nearby aspens. Later we showed the images to the park ornithologist. He said not only had we photographed a boreal owl, it was the first confirmed sighting of the species in Yellowstone National Park!*

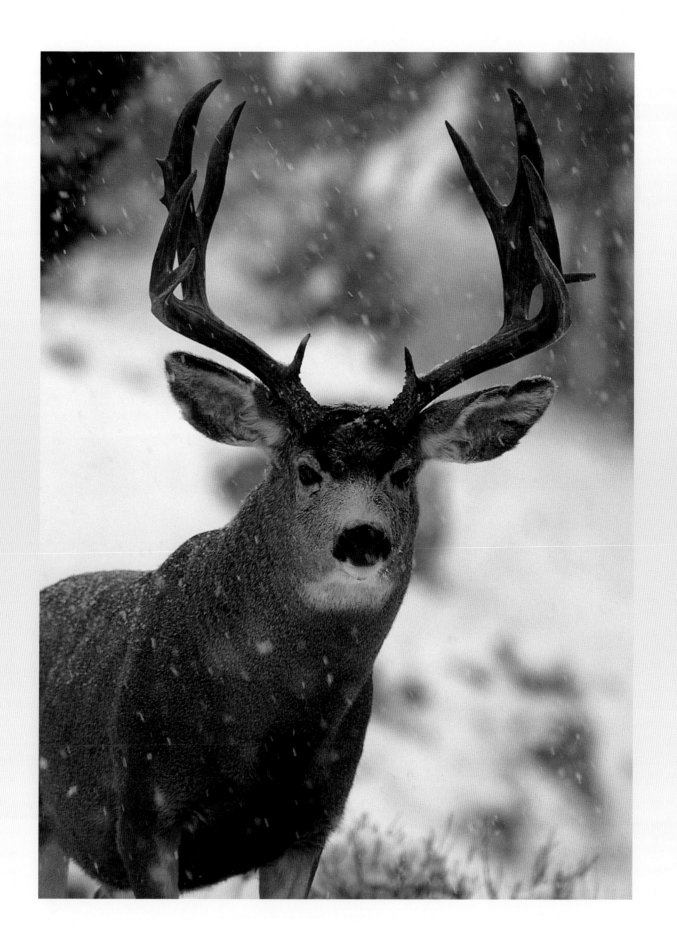

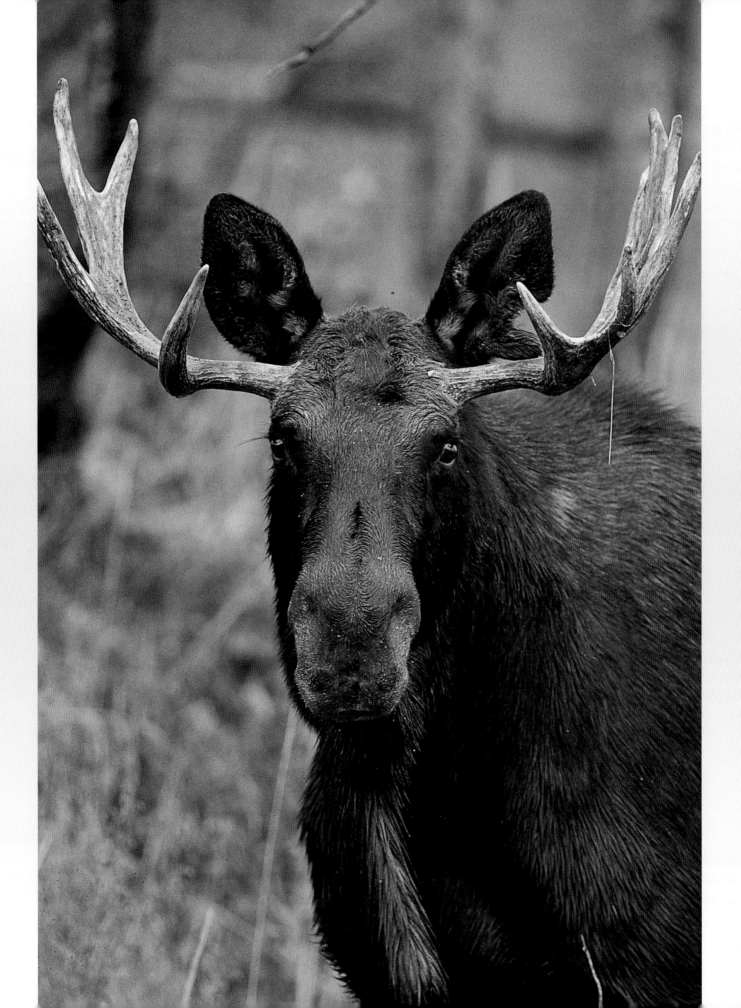

# Moose memories

*Then: When I first came to Yellowstone there were many moose around the Lake and Fishing Bridge areas. In fact it was common to see twenty moose from the road at Pelican Creek in the evenings. At Willow Flat between Mammoth and Norris you could always count on a handful of moose.*

*Now: It is uncommon to see moose, and there are only a few spots where they are viewed consistently. The best places are Floating Island Lake between Mammoth and Tower Junction and the lower slopes of Mount Washburn along Antelope Creek.*

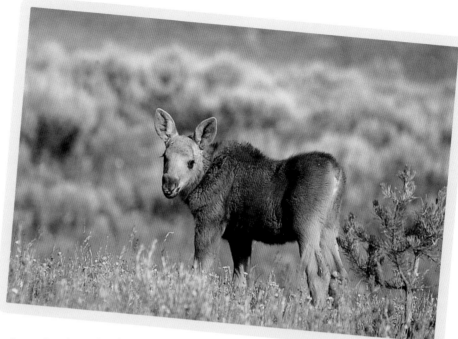

*ABOVE: Baby moose are something special. Long legged and big-eared, they always seem a little surprised at what's going on around them. Fortunately their mothers are very protective and keep all other creatures at bay.*

*FACING PAGE: A close-up portrait of a bull moose shortly after he has cleaned the velvet from his antlers.*

## VOLLEYBALL HAZARDS

We always had resident moose in the Lake complex. We called a male moose that hung around the employee dormitory "Marvin." We played volleyball at a couple of outdoor sites, and I can't tell you how many times our games were interrupted by moose showing up too close and not wanting to leave. One time while retrieving a ball that went into the trees, I ran into a mother moose with her newborn triplet calves. She gave chase and I ran for all I was worth. Fellow volleyball players told me she just jogged after me and soon quit. I thought she was breathing down my neck the whole way. Luckily for me, this was a moose that traditionally gave birth next to the ranger station and was accustomed to people. If this encounter had been with a less tolerant moose, I might have been injured.

## A CALF AT MY SIDE

One morning my wife stopped by the laundry where I was working and told me a young moose calf was standing by itself, crying in the rain. I grabbed my camera and went to investigate. There was the newborn, all alone. Somehow

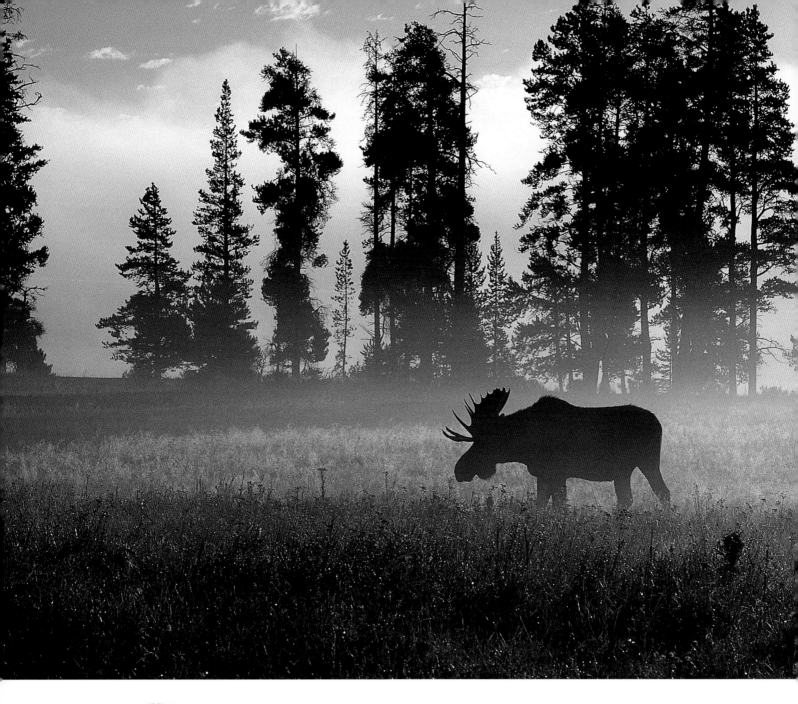

ABOVE: *A bull moose browses in a meadow in front of Lake Lodge. Moose were common in the Lake area in the mid-1970s and early 1980s. In recent years the moose population throughout the park has declined.*

the little fellow had become separated from its family, probably a cow with twins that had been in the area. At that young age a calf will follow any large animal and become imprinted on it. That's one reason mother moose keep every animal at bay. Sure enough, the calf came right to me. Oh no, I thought. I didn't want a mother moose chasing me, but now her calf wouldn't leave me. I suspected the mother was anxiously scouring the neighborhood and would eventually find her calf, but I couldn't leave because it followed me everywhere. Eventually I found a sheltered spot under some trees and sat down with the calf at my side. The little guy was so tired he went to sleep, and I sneaked away. An hour later I went back and there was mom and twins all together. After that I'm sure my calf stuck to her side like glue. I went back to work with a big smile.

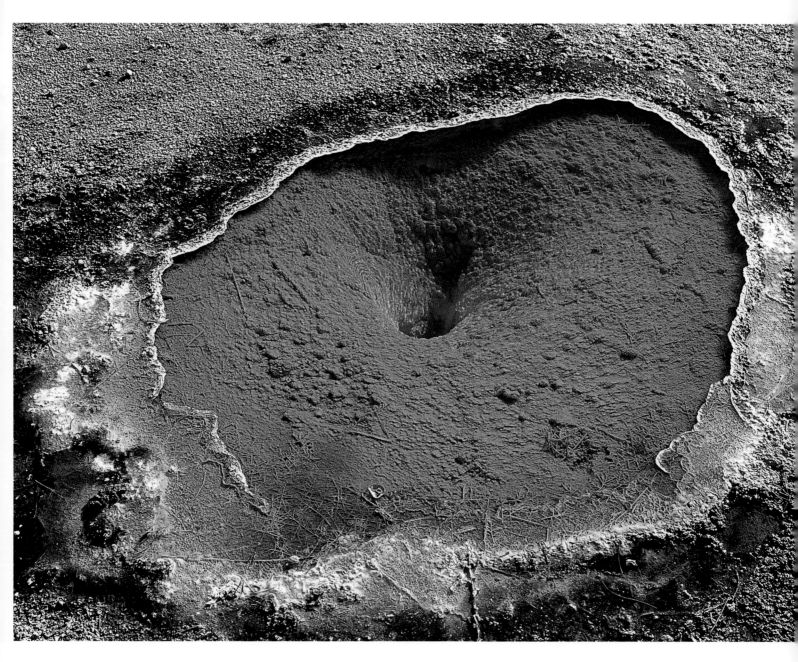

## ROAD-HOG MOOSE

Moose are large and can be very dangerous. My good friend Ron Shade and I had two exciting encounters within a couple of months while driving the park roads. The first incident occurred near the northeast entrance. The road from Mammoth to Cooke City is plowed during the winter, and so much snow can be piled along the sides it feels like driving in a tunnel.

One day a bull moose was walking on the road and did not want to leave it because of the deep snow. As a car coming from the opposite direction passed the moose, the bull reared up on its hind legs and pummeled the vehicle from hood to trunk with its sharp front hooves. Then he took a close look at us. We were

ABOVE: *A little unnamed thermal pool in Upper Geyser Basin. The basin, an area of about two square miles, contains the largest concentration of thermal features and nearly one-quarter of all the geysers in the world.*

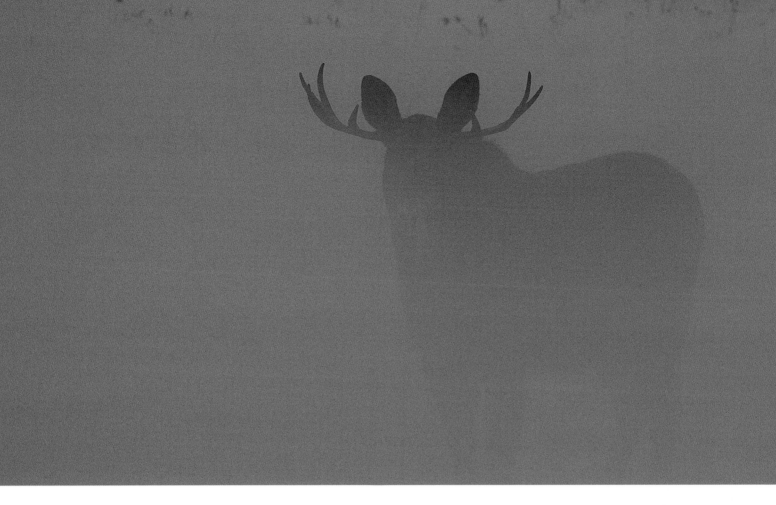

ABOVE: *Thick fog turns a young moose into a ghostly apparition.*

FACING PAGE: *Many thermally heated waters of Yellowstone remain open, or free of ice, in the winter, affording wintering areas for trumpeter swans from as far away as Alaska. Sometimes more than fifty swans can be found along the Madison River.*

driving a little Volkswagen Rabbit, which was about half the size of the moose. As the bull started running towards us, my friend put the engine in reverse and punched the gas pedal. It wasn't enough. The moose rapidly gained ground. Just as he was really getting close (and I'm thinking about hooves coming through the windshield), the little Rabbit belched a huge cloud of diesel smoke. That stopped the moose. This was the break we needed and we put distance between us. Eventually the moose made its way off the road and we resumed our journey.

The next episode took place in early spring just after the roads opened. We were in that same little Rabbit when we came up behind a moose walking on the road. As we approached to pass, the animal looked at us and then deliberately moved to the center of the road as if to say, "No passing. I was here first." Every time we approached, the moose looked back over its shoulder, flattened its ears, and gave us an evil stare. Having witnessed what a moose can do to a car, we backed off.

This went on for several miles. Then a big service truck pulled up behind us and passed. The moose moved out of the way for the truck but cut in front of us before we could follow it. That moose was just bound and determined that our puny little car was not going to get ahead. Finally we neared the large pullout for Obsidian Cliff. I told my buddy that whichever way the moose went, go the opposite way and fast. It worked. We finally passed that road-hog moose!

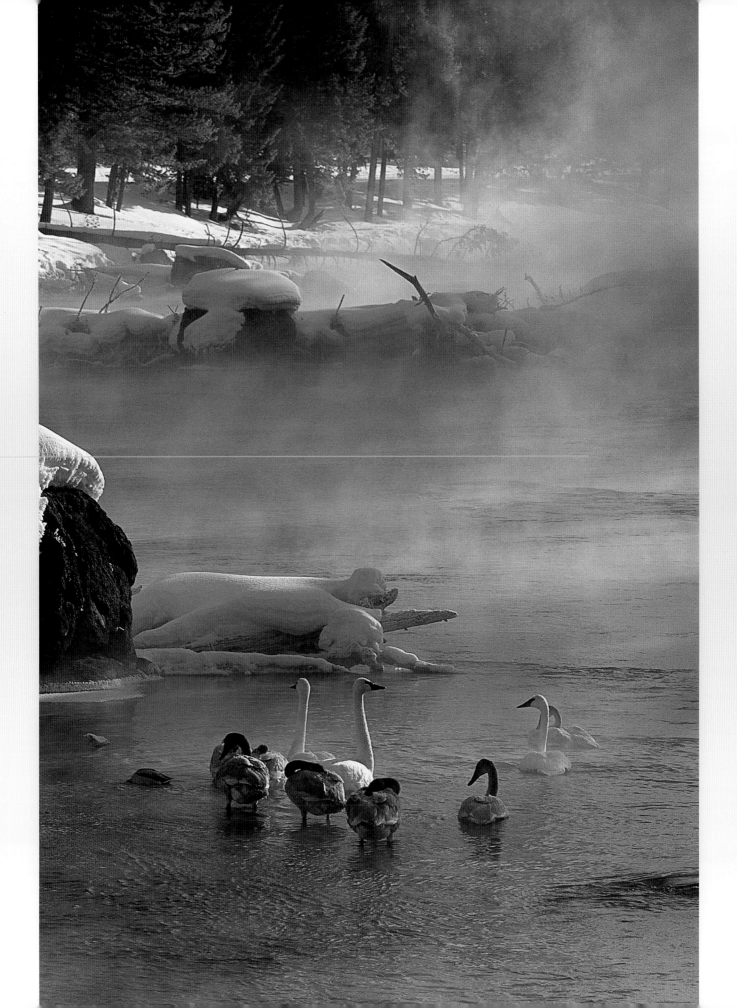

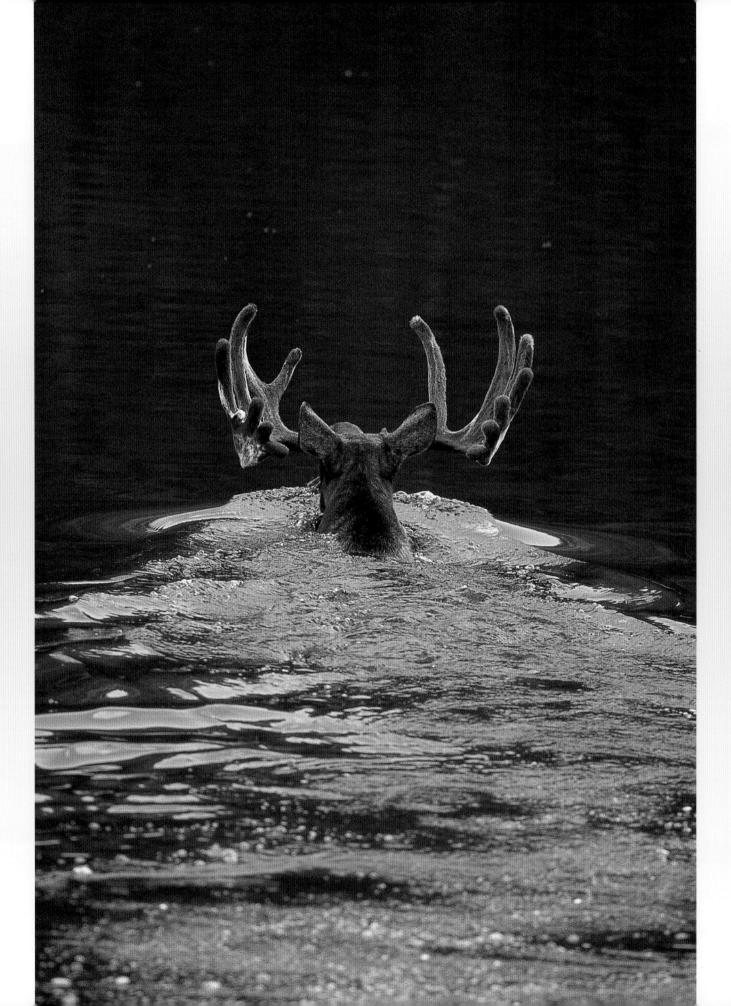

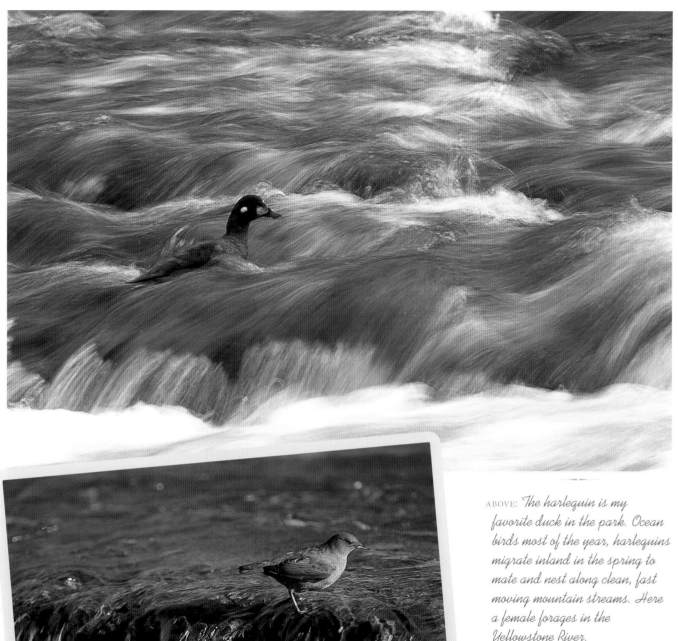

ABOVE: The harlequin is my favorite duck in the park. Ocean birds most of the year, harlequins migrate inland in the spring to mate and nest along clean, fast moving mountain streams. Here a female forages in the Yellowstone River.

LEFT: If you see a stocky, gray, wren-like bird with a short tail that is bobbing or dipping as the bird stands on a rock or log along a fast moving stream, then you are watching a dipper. Dippers can walk, completely submerged, along the bottom of a rushing stream and probe for insects, fish, and fish eggs.

FACING PAGE: A large bull moose swims across Floating Island Lake. Moose are good swimmers. Before giving birth, females sometimes swim to islands in Yellowstone Lake so they and their new calf will be safer from predators.

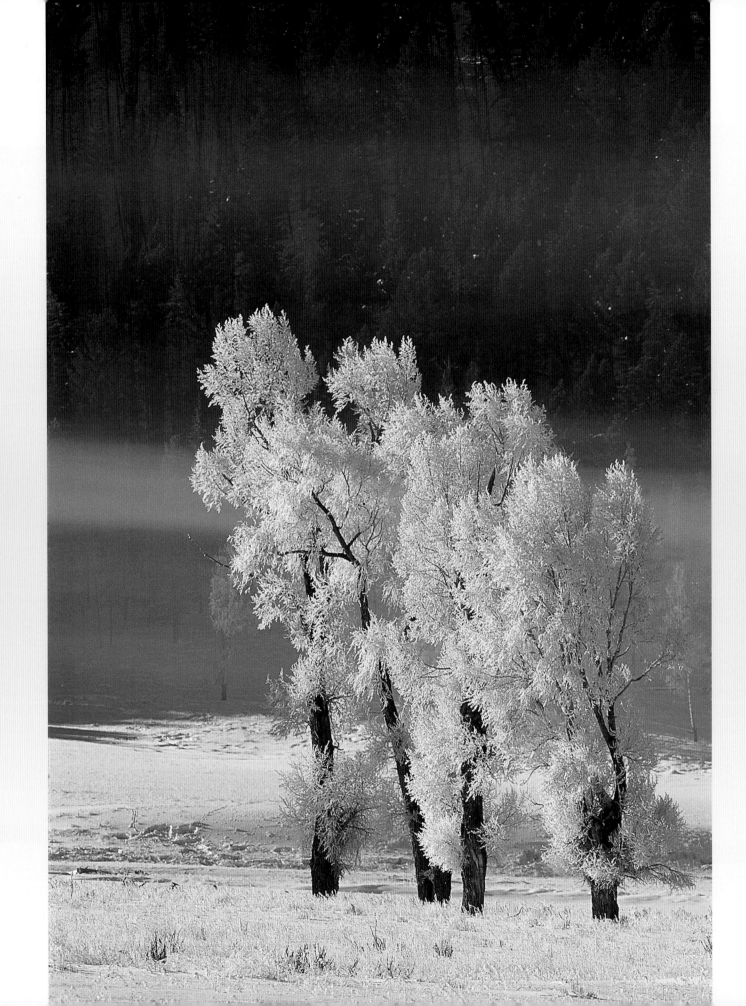

# Wolf memories

Wolves were re-introduced to Yellowstone National Park in the mid-1990s. From my perspective this has been one of the biggest changes in the park, with only the fires of 1988 having a larger impact on the ecosystem. Surprisingly, wolves are visible not only to biologists but also to the viewing public. The wolves have become such favorites that places like Lamar Valley, which prior to wolf re-introduction was a nice quite place with few visitors, is now populated with wolf watchers both summer and winter. There are days while driving the park roads that I see more wolves than coyotes. This is quite a change from thirty years ago when coyotes were the top dog in the park.

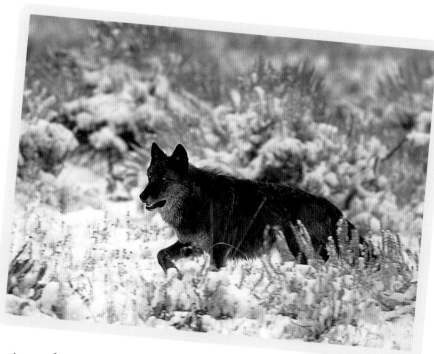

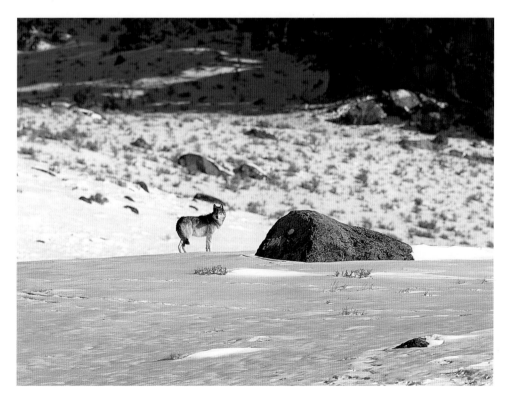

A large percentage of the Yellowstone wolves are black, and their color makes them stick out like sore thumbs during the winter. The wolf above showed no fear of my vehicle and stayed on the road in front of me for several miles. Every so often it moved off the road to check something in the sagebrush, allowing me to drive ahead and photograph it as it came past me again. Unlike most places in the world, Yellowstone's wolves are very visible to visitors, especially in places like Lamar Valley (left and facing page).

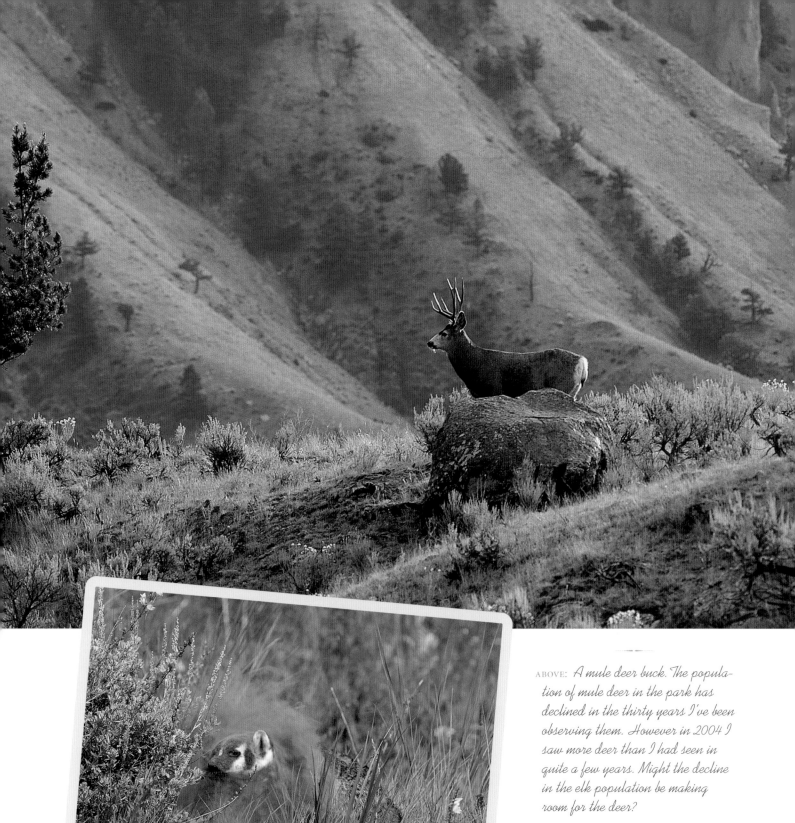

ABOVE: *A mule deer buck. The population of mule deer in the park has declined in the thirty years I've been observing them. However in 2004 I saw more deer than I had seen in quite a few years. Might the decline in the elk population be making room for the deer?*

LEFT: *The badger is one of nature's better excavators. This one is shaking off dirt after digging in a ground squirrel burrow.*

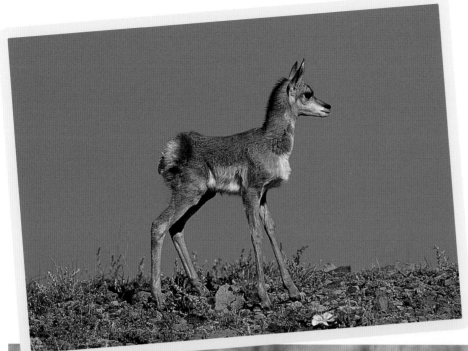

LEFT: *Look at those legs! Young antelope like this one can run like the wind only a few days after birth.*

BELOW: *Coyotes must enjoy early summer because ground squirrels are numerous and easy prey. Note that this coyote with a freshly caught ground squirrel is just starting to shed its winter coat.*

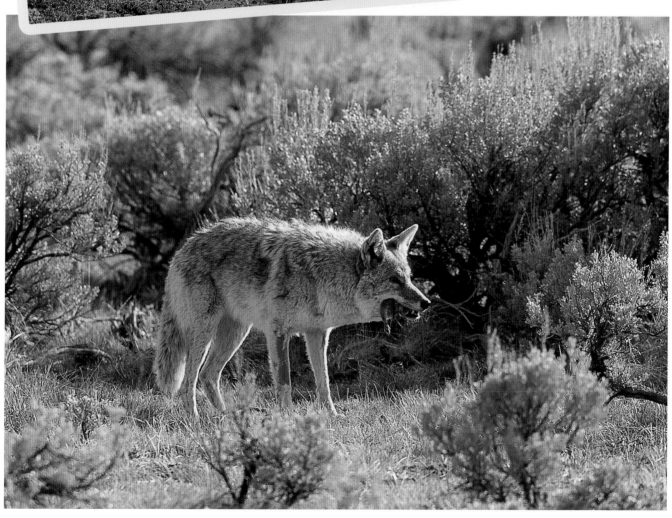

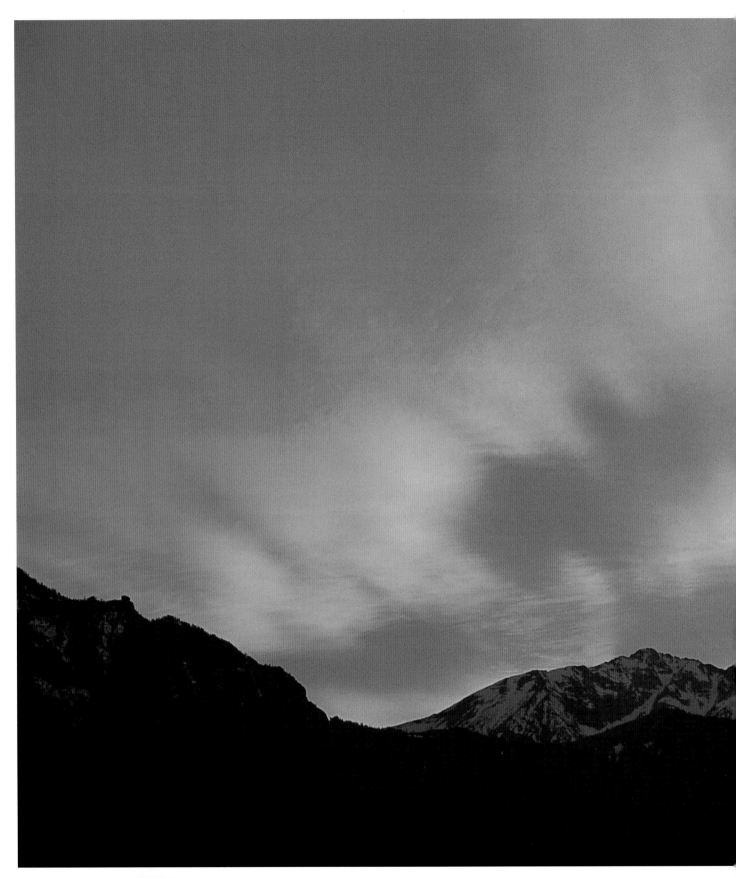

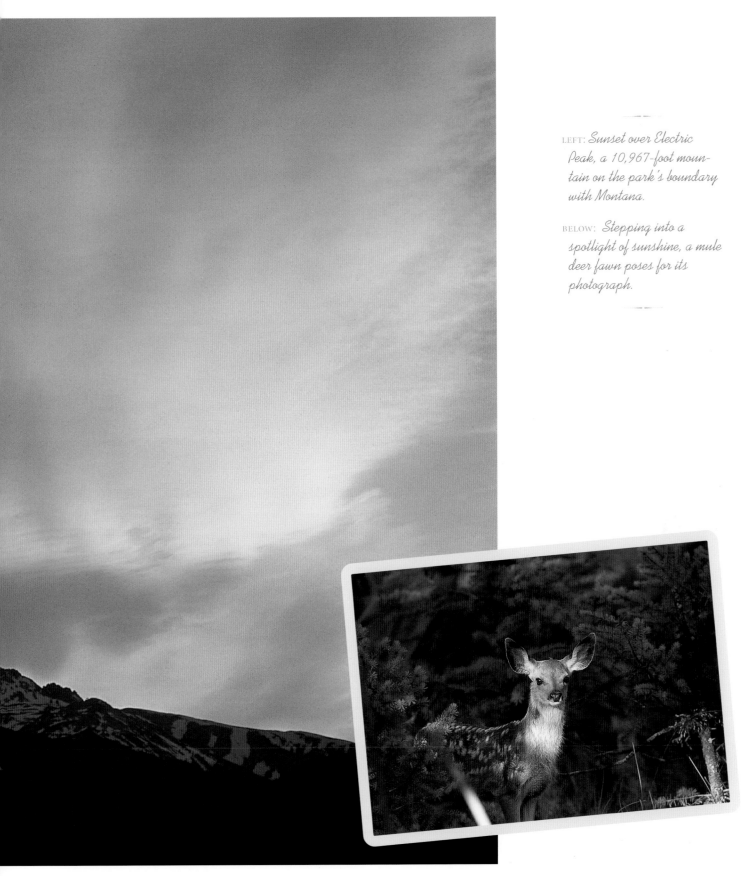

LEFT: *Sunset over Electric Peak, a 10,967-foot mountain on the park's boundary with Montana.*

BELOW: *Stepping into a spotlight of sunshine, a mule deer fawn poses for its photograph.*

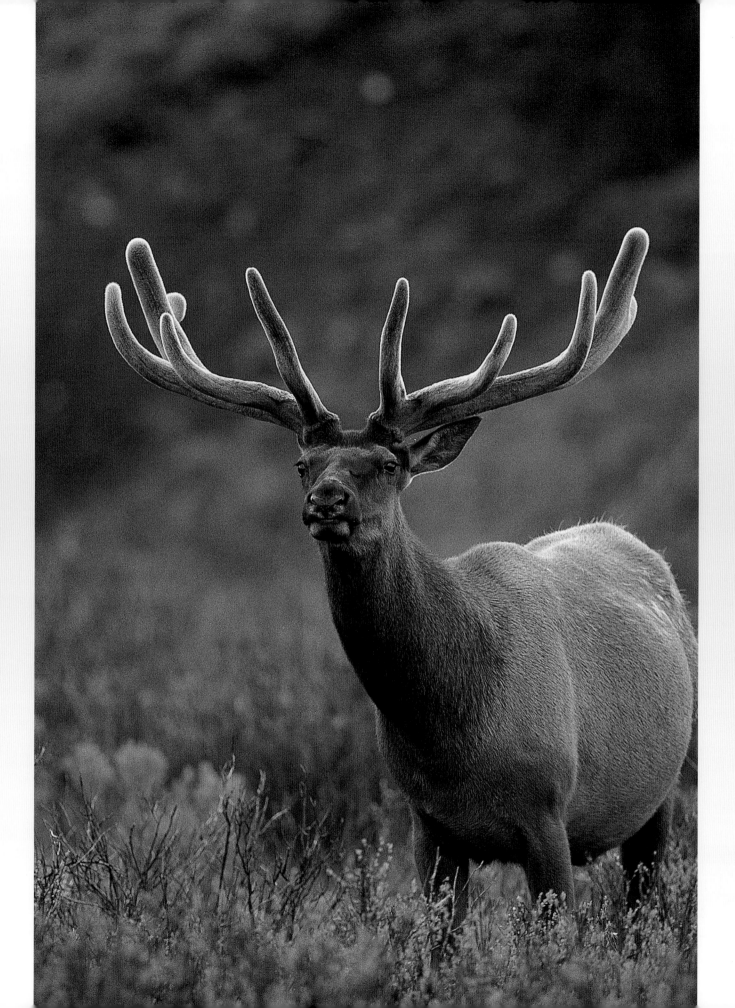

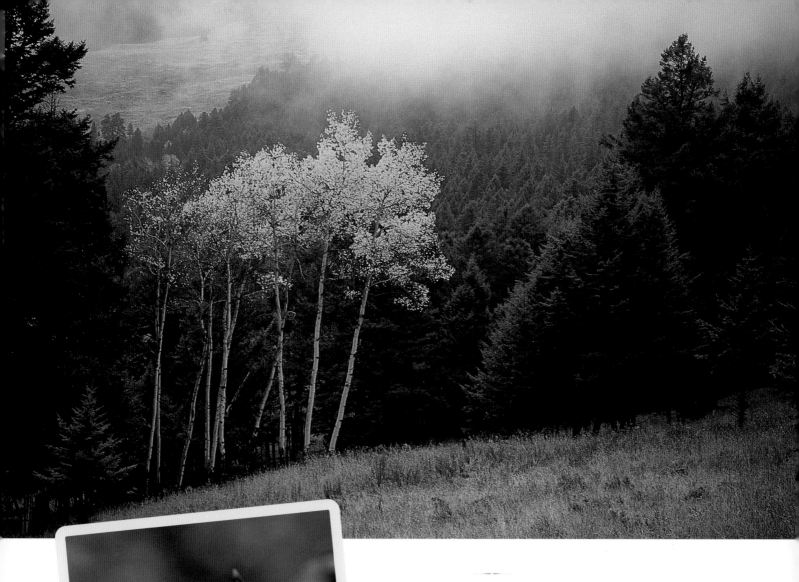

ABOVE: *Aspen in fall color along the slope of Mount Washburn.*

LEFT: *Wild rose hips are a favorite food of bears in the fall.*

FACING PAGE: *Elk antlers grow at one of the fastest rates in the animal kingdom—more than an inch per day. This bull's large antlers are covered in the fuzzy "velvet" that nourishes the growing antler. In late summer the velvet will dry up and be rubbed off, exposing the fully-grown hard antlers.*

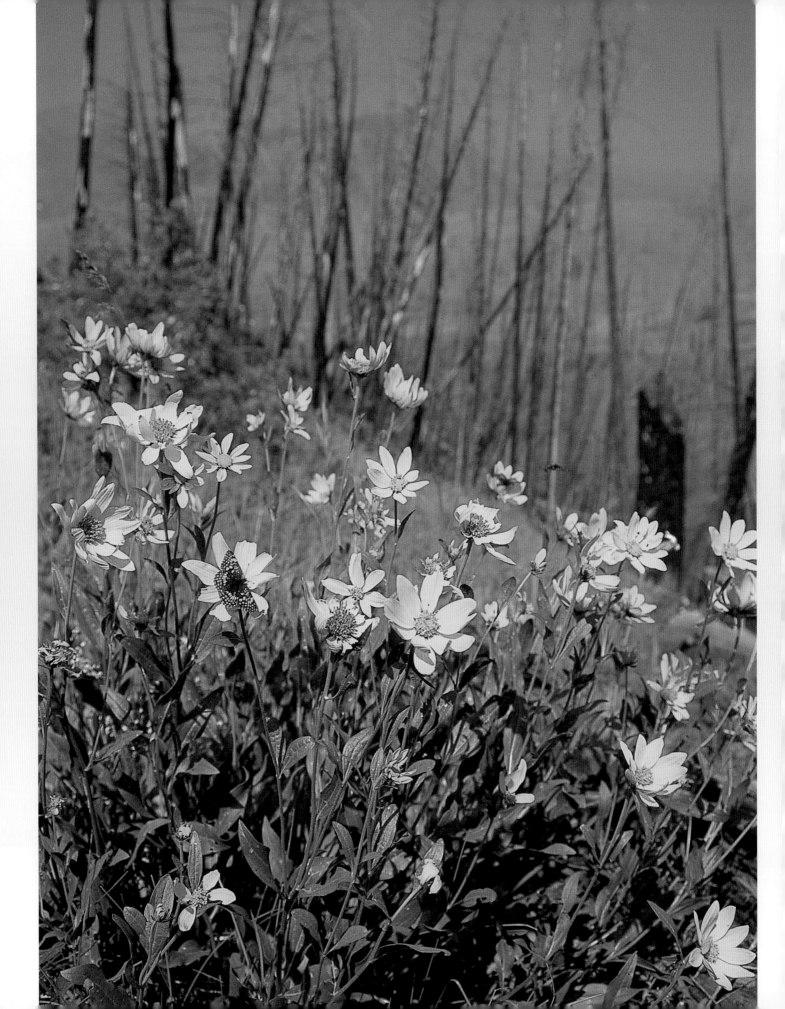

# Fires of '88 memories

I spent most of the summer of 1988 working on photo assignments in the park. First I worked for *National Geographic* on a fly-fishing story, which ended up a bust because there was too much smoke in the air. Then I worked for the park concessionaire to photograph visitor activities. Once again smoke got in the way. Finally I offered my services part-time to the National Park Service to photograph firefighters. On the day the Marines arrived, I was the only media photographer to go out with them. That day I got my first lesson in the dangers associated with fighting fires as burning trees kept falling all around us.

One very smoky day I dropped a lens cap and became dizzy after bending over to pick it up. I figured that day I must have breathed in the equivalent of several packs of cigarettes.

Much comment has been made on how few large animals were actually killed by the fires. For the most part, the animals went about their daily business, often with flames just a few feet away. There was certainly no panic as you might see in a cartoon with hordes of animals running ahead of a wall of flames. But during the following winter, animals were starving by the hundreds. By spring, carcasses were numerous. In one burned area where bull elk typically wintered, I counted twenty-one carcasses. It seemed they were reluctant to leave their traditional area even though it had no food. The following spring and summer, grizzly and black bears fed well on the protein-rich carcasses.

ABOVE: *After the fires of 1988, huge fields of the appropriately named fireweed were common. This flower is one of the first plants to pioneer burned areas.*

LEFT: *A smoke-screened sunset near Otter Creek in 1988.*

FACING PAGE: *Little sunflowers bloom in an old fire burn near Tower Junction,*

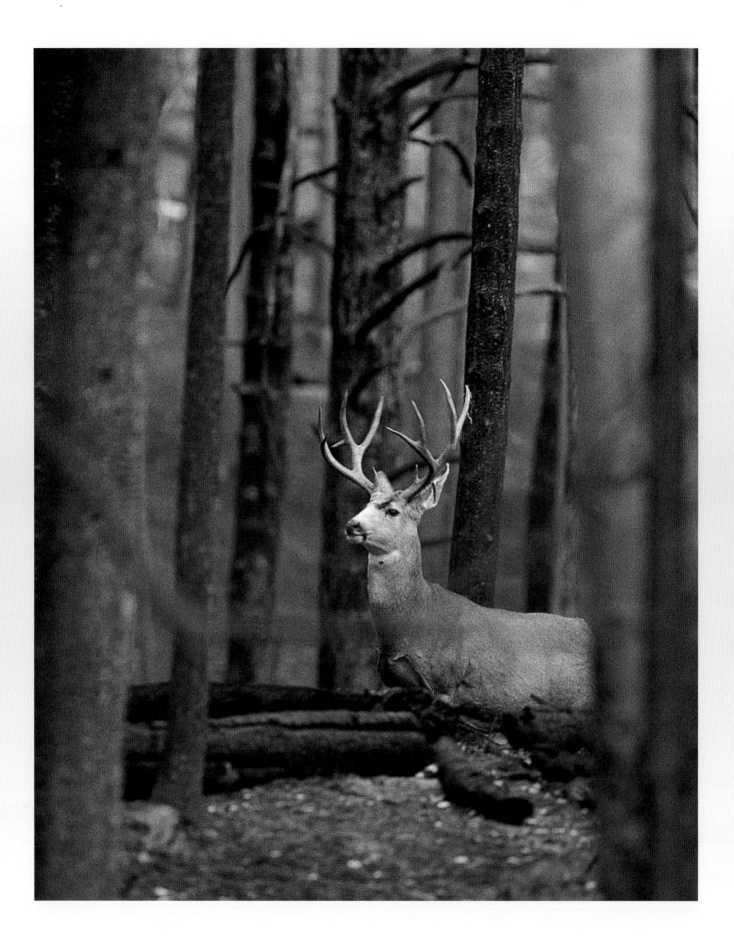

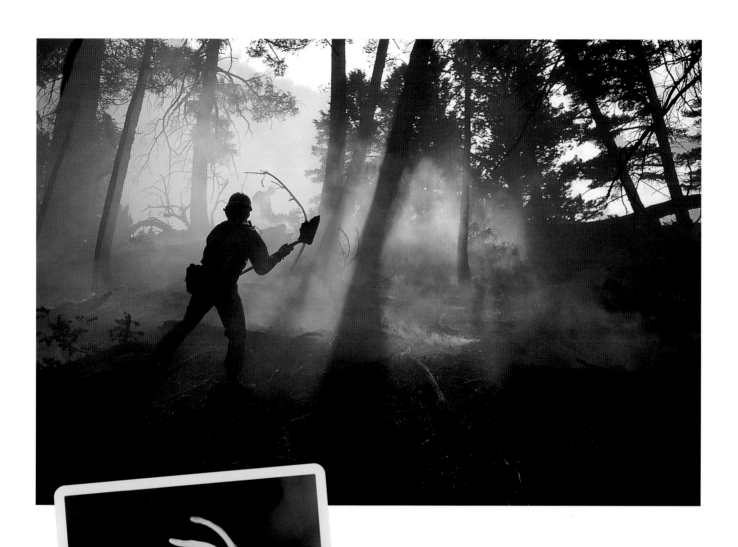

RIGHT: *During the Fires of 1988, firefighters from many sources came to Yellowstone. Here a U.S. Marine swings a shovel on a fire line.*

LEFT: *Glacier lily.*

FACING PAGE: *A mule deer buck moves through a burned forest.*

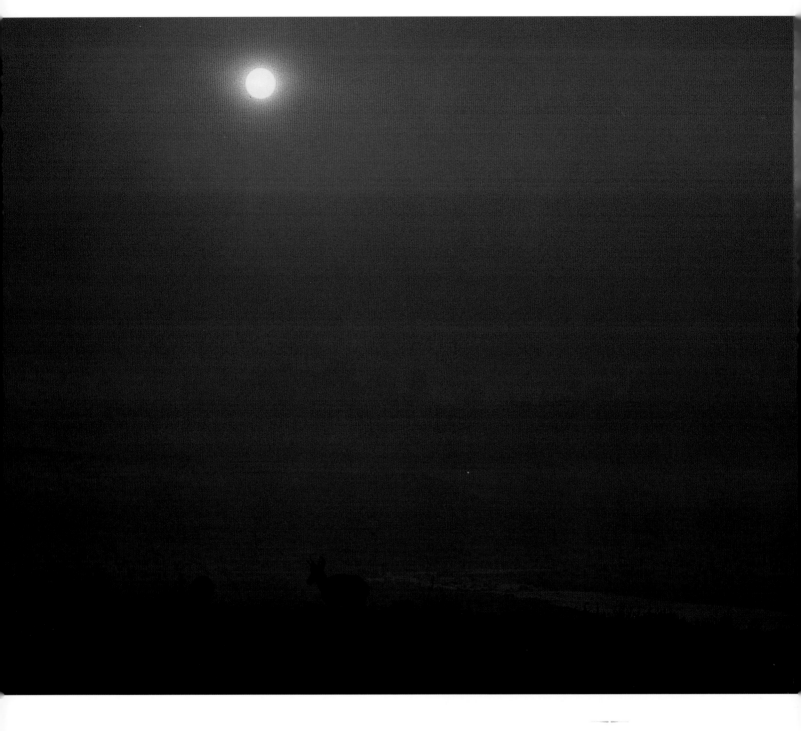

ABOVE: *A pronghorn antelope grazes in the very thick smoke haze of the Fires of 1988.*

FACING PAGE: *Like a fiery geyser, flames erupt in the forest near West Thumb.*

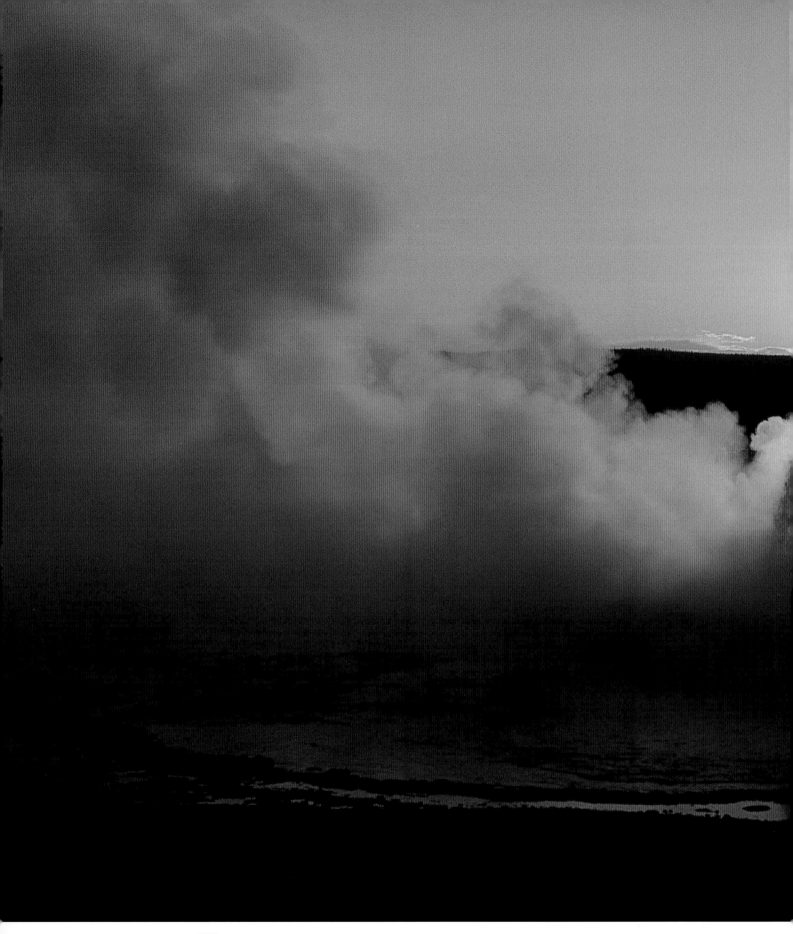

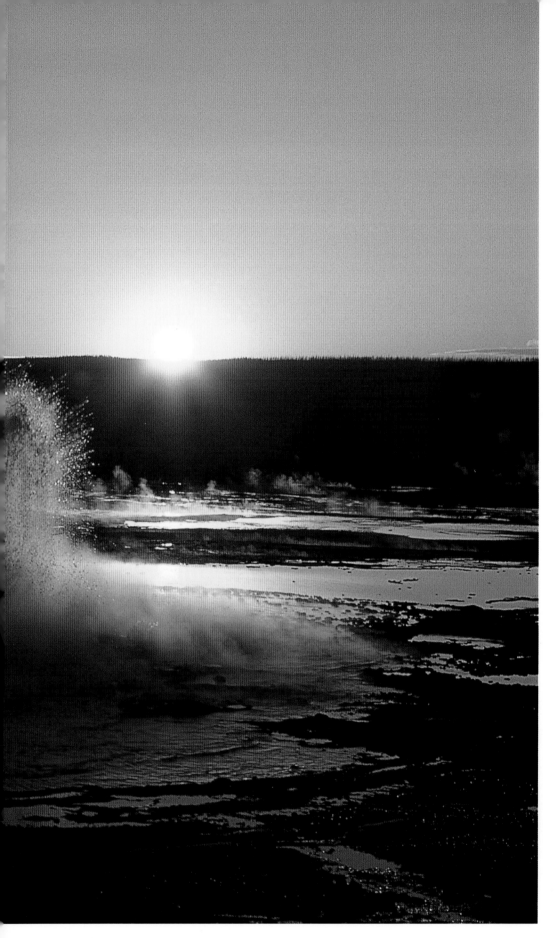

Clepsydra geyser erupting at sunset. Unlike other geysers that you have to wait for, Clepsydra erupts almost constantly. It's one of my favorite geysers. It was first described in 1873, a year after Yellowstone was made a national park

## ABOUT THE PHOTOGRAPHER

Michael H. Francis is a full-time nature photographer specializing in large mammals of North America. His wildlife images have appeared in hundreds of publications, including *Field & Stream, Outdoor Life, Sports Field, National Wildlife, Ranger Rick, Audubon, Time,* and *Natural History.* Michael is also the sole photographer of 26 books, including four for Riverbend Publishing (*Yellowstone Memories, Watching Yellowstone and Grand Teton Wildlife, Watching Glacier Wildlife,* and *Jackalope).* He is an active member of The North American Nature Photography Association (NANPA) and served as its president in 2003. He is a graduate of Montana State University. Mike worked for fifteen seasons in Yellowstone National Park, managing hotels and lodges for the concessionaire. He lives in Billings, Montana, with wife Tori and daughters Elizabeth and Emily, along with his 25 turtles and tortoises.

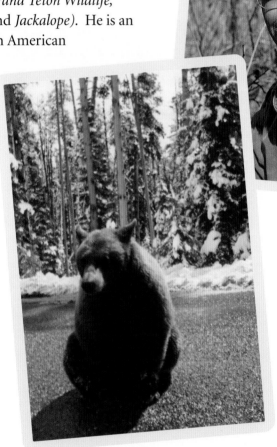

GARY LEPPART

*Mike Francis, above, has taken hundreds of thousands of photos in Yellowstone National Park over the past thirty years. The black bear at left was one of his first pictures, taken in 1974.*